DRAWING *from your* IMAGINATION

D&C

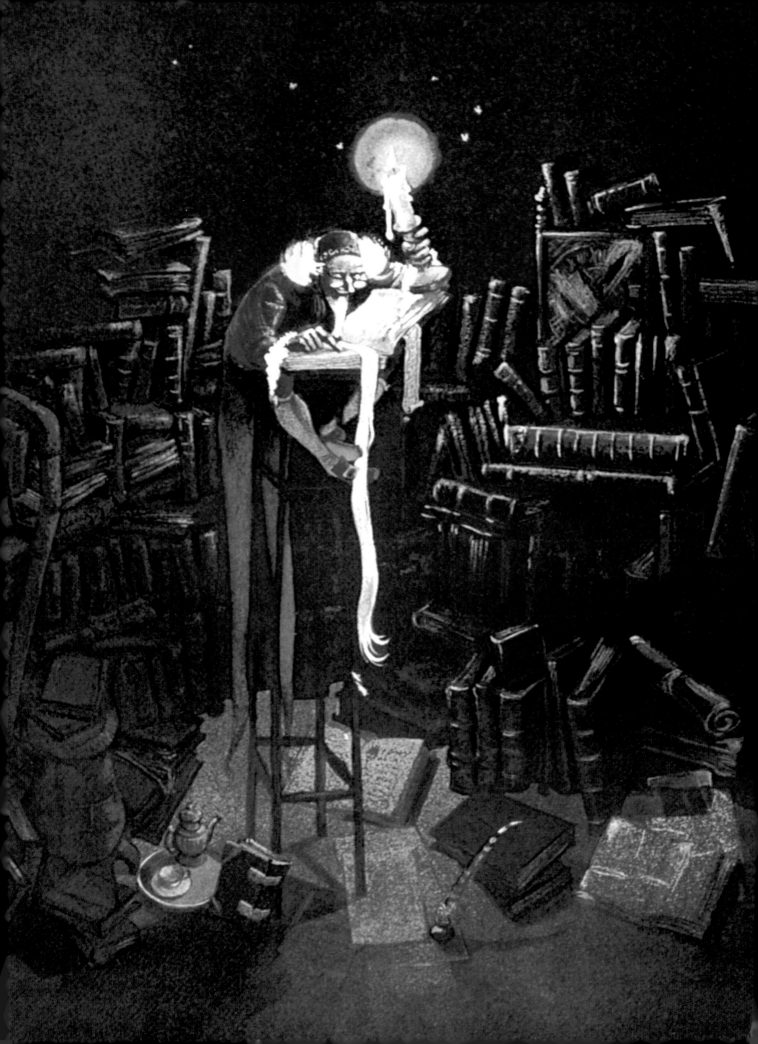

DRAWING *from your* IMAGINATION

RON TINER

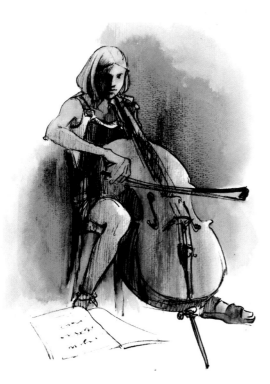

Jodi – a coloured drawing of my granddaughter
practising the cello.

*This book is dedicated to my wife,
Riki, for her patient forbearance
during the writing of this book, my
sons Paul, Marcus and Jonathan,
my daughter Fiona and my
granddaughter, Jodi.*

A DAVID & CHARLES BOOK
Copyright © David & Charles Limited 2008

David & Charles is an F+W Publications Inc. company
4700 East Galbraith Road
Cincinnati, OH 45236

First published in the UK in 2008
First published in the US in 2008

Text and illustrations copyright © Ron Tiner 2008

Ron Tiner has asserted his right to be identified as author of this work
in accordance with the Copyright, Designs and Patents Act, 1988.

A catalogue record for this book is available from the British Library.

ISBN-13: 978-0-7153-2925-2 paperback
ISBN-10: 0-7153-2925-1 paperback

Printed in China by SNP Leefung
for David & Charles
Brunel House Newton Abbot Devon

Senior Commissioning Editor: Freya Dangerfield
Editor: Bethany Dymond
Art Editor: Martin Smith
Project Editor: Paul Barnett
Proofreader: Diana Vowles
Production Controller: Ros Napper

Visit our website at www.davidandcharles.co.uk

David & Charles books are available from all good bookshops; alternatively you can
contact our Orderline on 0870 9908222 or write to us at FREEPOST EX2 110,
D&C Direct, Newton Abbot, TQ12 4ZZ (no stamp required UK only); US customers
call 800-289-0963 and Canadian customers call 800-840-5220.

Contents

Afghan warrior – a narrative frame for the graphic novel *Maiwand*.

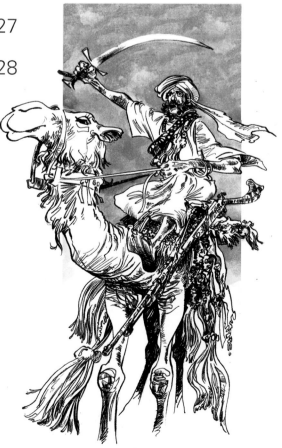

Introduction

From time to time most creative illustrators meet the fan who insists on asking them, 'Where do you get your ideas from?' The obvious answer – 'From inside my head' – suggests a follow-up question: 'How do you organize your head so that it gives you ideas whenever you want it to?'

That's a question people usually find difficult to answer. The general assumption is that some of us have a good imagination while everyone else simply doesn't.

Art colleges and university art departments tend to build up a kind of mystique around the notion of creativity, as if such an ability could manifest itself only in people magically gifted at birth. It's clearly the case that the naturally gifted have the potential to go faster and farther than the rest of us, but even so, we lesser mortals are not necessarily condemned to a lifetime of unimaginative plodding!

Most of us seem born with a natural aptitude for something – acting, mathematics, football, whatever. It might simply be that someone is a good conversationalist or has the knack of making other people feel at ease. This doesn't mean that if we're born without any special aptitude in a particular area, we have no chance of ever achieving anything worthwhile in that sphere. Anyone can be taught to play football, and with a lot of training and practice, become very good at it. The same is true of drawing, because the urge to draw is natural to all of us, as any parent will attest. Developing skill in drawing carries with it the additional bonus that, with the right kind of practice, creativity – in the sense of gaining the ability to get good ideas – can be encouraged to grow along with it.

Below – 'Dancing Gnomes', part of a drawing derived from sketches done while watching the film *Darby O'Gill and the Little People* (1959).

Below – A cover illustration for OUP's 1999 simplified text version of *Kidnapped* by Robert Louis Stevenson (1886).

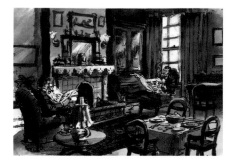

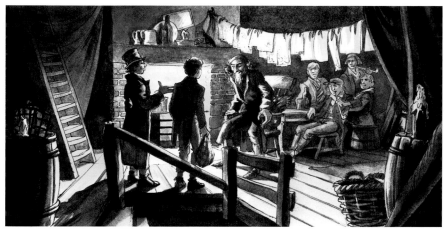

A colour rough for an illustration of the sitting room in Sherlock Holmes's 221B Baker Street (**above**) and for Oliver Twist's arrival at Fagin's 'thieves' kitchen' (**right**).

Here I offer a means to unlock the doors to the creative imagination that is present in all of us simply because we're human. Obviously, though, there's little point in artists having all the creativity in the world if they don't have the drawing skills to express it. The advice I have to offer here involves the development of a lively intuitive imagination through a specific kind of drawing practice.

In designing the pages of this book my aim has been to say what I want to say in two languages: visual and verbal. The pictures have as much to say as the words. I hope that you find both words and pictures inspirational as you seek to unlock your creative imagination.

Above – A two-colour illustration for OUP's 1999 simplified text version of *The Eagle of the Ninth* by Rosemary Sutcliffe (1954).

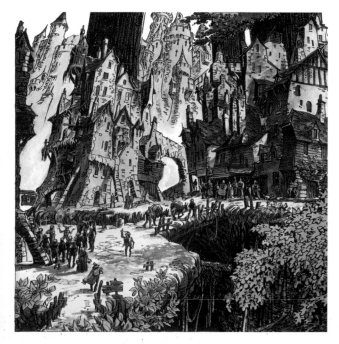

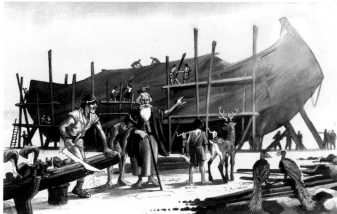

Above – Noah and his family in the process of building the Ark.

Left – Nottingham, a narrative frame from the graphic novel *Lincoln Green*.

Drawing the real world

It might appear odd to begin a book about imaginative drawing with a chapter about drawing from life. But it's not as paradoxical as it seems. Recent brain function research has shown that regular practice in drawing and sketching from observation of the real world does have a significant effect on the ability to think creatively.

Though you may not realize it, drawing from life involves the creative imagination. The more you draw what you see in everyday reality, the more you'll be exercising your imagination, and consequently the greater the extent to which that creative part of the brain will develop into a source of ideas and concepts.

So if you wish to become a successful imaginative artist, the best advice I can offer you is: be prepared to draw anything and everything you see.

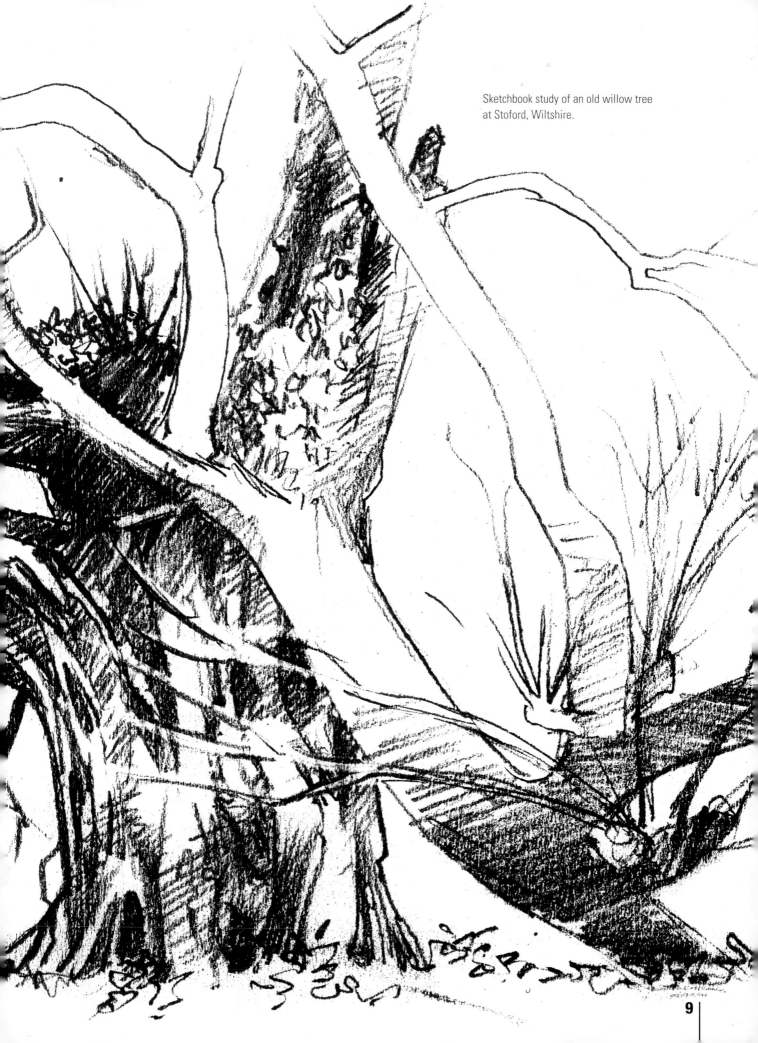

Sketchbook study of an old willow tree at Stoford, Wiltshire.

Frequent use of a sketchbook is the best way of developing your skills as a creative artist. Take one with you wherever you go. Draw in it whenever you have a few spare moments – at the bus stop, in the library, on the train or just in the street or at home. Regular practice is what brings results, so I urge you to make sure you do some drawing every day. Draw everything that catches your attention, large or small. Draw your world!

The more competent you become at drawing what you see the more readily you will develop the ability to draw what you imagine. Constant practice is the key to success in this field of endeavour, just as it is in any other.

Anything you do every day you'll become good at; that is a fact of life. Footballers, ballet dancers and musicians practise their skills constantly, making sure they do at least some training every day, because they realize that this is the only way to achieve the high level of the skill they need. For the visual artist, skill and creativity develop together, so you should be prepared to make a similar commitment.

And it isn't such a tall order as you might at first think. A sketchbook and pencil are not especially cumbersome items to carry around with you. Many artists are happy with sketchbooks they can easily fit into a pocket, but I prefer A4 sketchbooks -- I feel constrained by anything smaller. I recommend a sketchbook with stiff covers that offer firm support as you draw.

All the abilities you require to create convincing pictures of exotic locations like Atlantis and Valhalla can be developed through regular practice drawing everyday subjects like suburban street scenes and even objects found in the home.

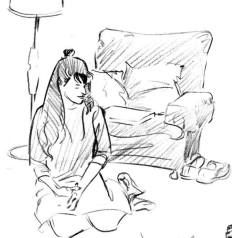

Above – There's never a wrong time to draw something that catches your attention. This sketch of my granddaughter was done in the calm atmosphere of an evening at home. The colour was added later.

Left and below – These sketches of a snowy country lane in Northumberland, England, of a family friend watching TV and of a decrepit old corner shop are typical of the kind of drawing practice that enhances your practical expertise while simultaneously enriching your imagination.

For further convenience I use a 2mm clutch pencil (see photograph below) rather than an old-style wooden one. Such pencils are far less likely to break in transit, and there's a handy sharpening device incorporated into the press-button at the top. As for the lead, I use a B or a 2B. Anything softer is too prone to smudging, while anything harder severely limits the range of dark-to-light tones I can achieve.

A decaying country mansion, a tree in winter, people at a bus station, a view from a multi-storey car park, waves at the seaside, a puddle by a gate – all were done for the simple pleasure of recording in pencil what I saw but each made its own small contribution to my ability to draw from imagination. The wide-ranging subject-matter is typical of what may be found in the sketchbook pages of any committed graphic artist.

Introducing your imagination

The pictures on these pages come from the dozens of sketchbooks that are stacked on shelves in my studio. Those sketchbooks are packed with observational drawings as well as idea sketches and preparatory drawings for imaginative projects.

Some of the drawings you see here date from long ago, when I was just starting out as a professional artist and was frustrated by what I saw as the lack of creativity in my work. The notion was current that imaginative artists were people who were *born talented* – there was no other way to become one. What my sketchbooks prove to me, as I look back through them, is that you don't need to be *born talented*. You simply need ambition and the will to do it.

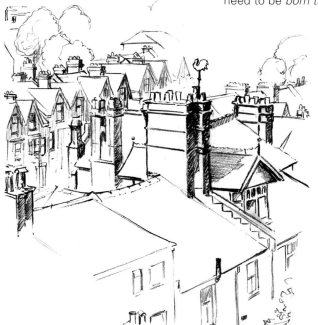

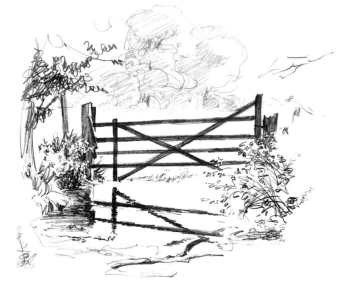

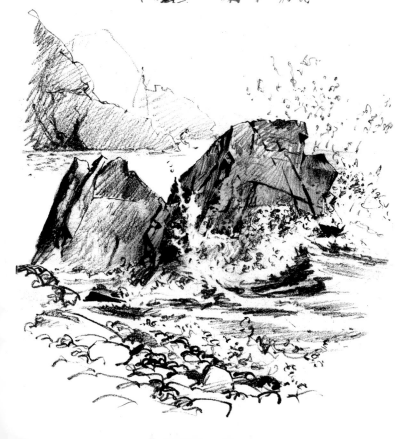

Everyone has a creative imagination; it's just that some of us have to work harder than others to access it. This isn't wishful thinking on my part. As I have said, brain-function researches have shown that activities like the kind of observation drawing I'm advocating in this chapter do have a significant effect on a person's ability to think creatively. The recent studies were foreshadowed in two classic books by Betty Edwards: *Drawing on the Right Side of the Brain* (1979, with revised editions since) and *Drawing on the Artist Within* (1986). Practices I stumbled upon in my early career simply because I was fascinated by the process of drawing are now known to enhance the development of an inventive imagination.

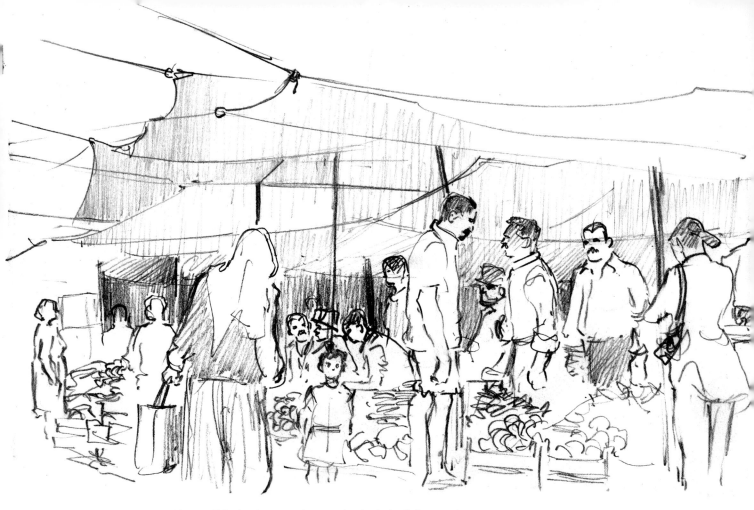

Above – This sketch was made on market day in the little coastal town of Turgutreis, Turkey, where children are taught English from the age of six. The little girl just left of centre came and chatted to me while I worked.

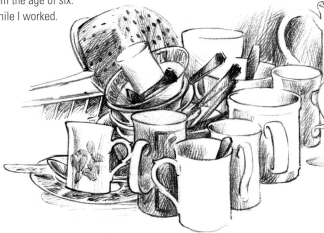

The more observation sketching you do, the more sensitive you'll become to your surroundings . . . and the more you'll be inclined to spend a little time drawing them. Constant practice will have the effect of increasing your skill and keeping your visual memory sharp, and at the same time, you'll begin to notice an enhanced imaginative quality in the drawings you produce, and in the new concepts they spark off in your mind.

Don't expect it all to happen at once. It's a gradual process. But it's also an inevitable one.

If you draw daily from direct observation you'll develop a sureness of touch and a level of perception it's probably impossible to achieve by any other means. But perhaps the biggest advantage of all is that you'll gradually acquire the knack of knowing how to make a picture out of every idea that occurs to you.

Nothing is too insignificant to be worth drawing. The stack of dishes you should have washed up after dinner could offer as interesting a pattern of shapes and shadows as any architectural marvel or handful of priceless jewellery. Just about everything you lay eyes on could make a suitable subject for a drawing. This willingness to draw any scene or object is one of the keys to unlocking your imagination.

Looking back through old sketchbooks will remind you of aspects and details of pattern and structure which you may not have been noticing for some time in the world around you. The practice of constantly sketching really does open our eyes to the shapes, textures and colours of our everyday world.

Drawing light

Ever since the late 19th century, when the Impressionists introduced a new way of thinking about visual art, one thing has dominated all others as a subject for drawing and painting. That subject is light.

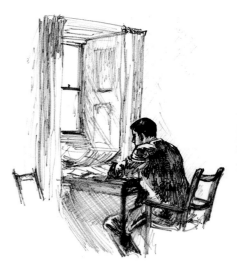

Above – Form and outline are often our main concerns in drawing. Portraying the light can sometimes alter our perception of the subject. This sketch was made in a small tower room in Alnwick Castle, Northumberland, England, where I studied for a short time.

In the colour sketch (**above**), one of my students does the washing up. The drawing (**left**) shows the basement staircase in the building (now demolished) that once housed the Illustration Department of Swindon College of Art in England. If I'd drawn it in simple outline, ignoring the effect of the light, it would probably have looked pretty dull.

Right – This colour sketch was made in the studio at the Swindon School of Dance as the students prepared for a practice session.

Above – Holiday sketch of sunset on the cliffs of Sorrento, southern Italy.

Whenever we look at anything, it is the light reflected from it that enters our eyes and is then interpreted by our brain in terms of colour and tone. That's the process of seeing.

When starting to draw, we tend to interpret shape and form in terms of outline – we simply put a line round everything, and think that's all a drawing is. In real life, of course, we don't actually see lines at the edges of things, so all that such a drawing can hope to do is remind us what shape a thing is, and drawings can do a great deal more than that. Drawings that show an awareness of light can summon sensations and emotional responses that evoke unique experiences in our lives.

Of course, we rarely abandon line altogether. But as we develop our perceptions through practice, we begin to see in a more profound way, and the quality of the lines we draw can evoke light, weight, atmosphere and surface form as well as shape. The hatchwork and patterning in the drawings on these two pages are specifically aimed at recording the effect of the light.

Above – Sketch of a summer woodland in Cornwall, England.

People

When I'm out sketching, there's nothing I like to draw more than people. It is best to do this as unobtrusively as possible: if people know you're drawing them they tend to become self-conscious and artificial.

Select a venue where people will not be moving about too much: a bus stop or a railway station platform, a pub or a café, a beach where people are sunbathing. Keeping your back to a wall makes it easier to disguise what you're doing and reduces the risk of your attracting 'helpful' spectators.

Draw what you see. You'll find you're recording characteristic proportions, postures, body language and gestures in a way you never could with a posed model or working from photographs. Over time you'll build up a rich archive of figure reference material that will prove invaluable when it comes to creating convincing characters for your imaginative pictures – not necessarily because you'll have already captured someone you can simply graft into the picture, but because your long experience of observing and drawing real people will have given you the knowledge you need to create convincing imaginary figures.

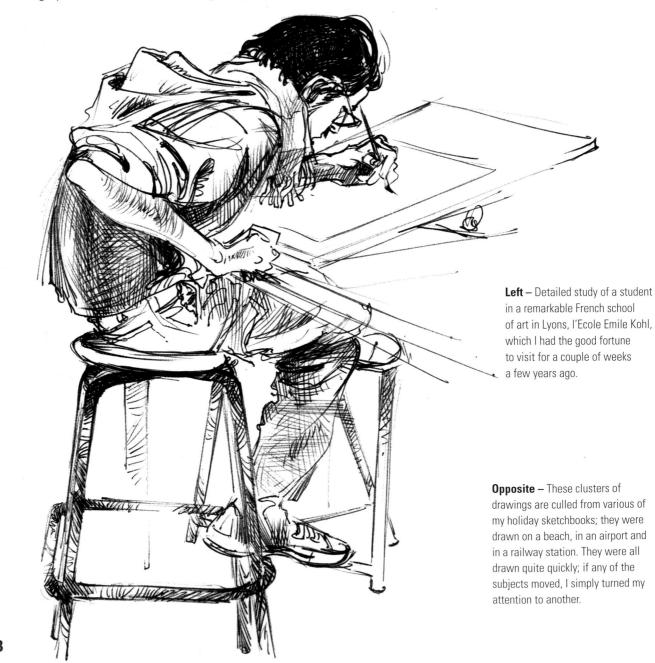

Left – Detailed study of a student in a remarkable French school of art in Lyons, l'Ecole Emile Kohl, which I had the good fortune to visit for a couple of weeks a few years ago.

Opposite – These clusters of drawings are culled from various of my holiday sketchbooks; they were drawn on a beach, in an airport and in a railway station. They were all drawn quite quickly; if any of the subjects moved, I simply turned my attention to another.

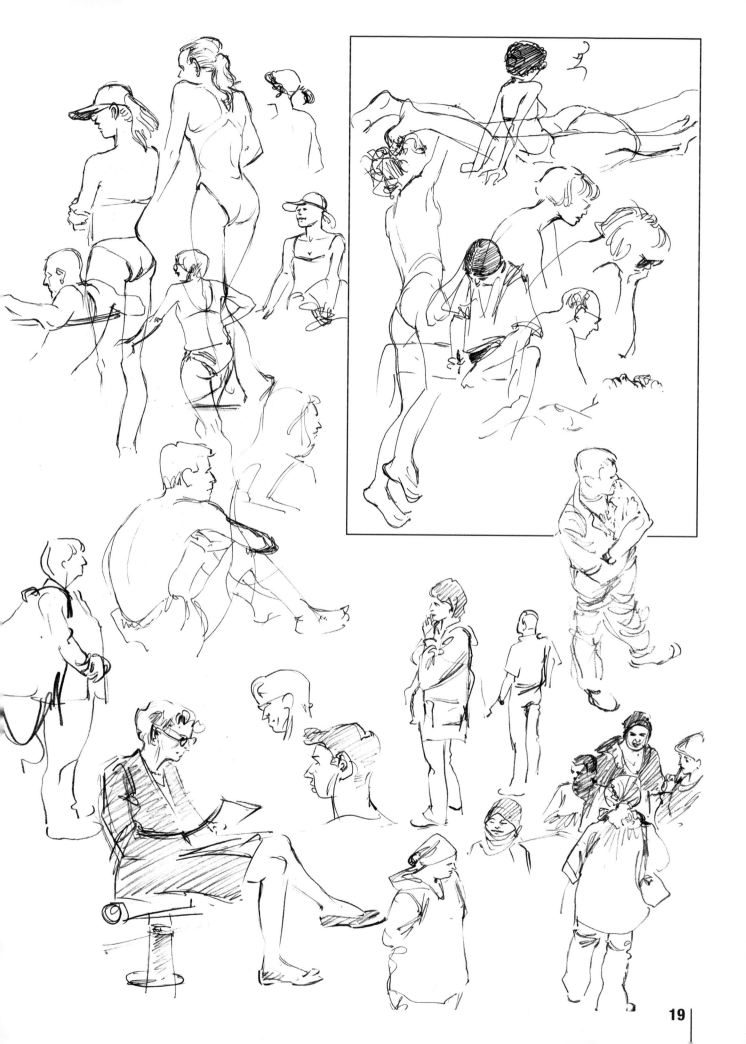

Sketching people step by step

I have often been asked how one should go about sketching people in the real world. Many youthful artists feel quite daunted by the prospect of this, and simply don't know where to begin. In truth, every artist has his or her own method, but on these two pages I outline the way that works for me. Adapt it until you're happy with it for yourself.

For the sake of this exercise, imagine you're watching and sketching the two men in the photo. We'll start with the man on the right, since he's in profile and you can see at a glance the significant outlines you need. The secret of success in high-speed sketching is to fix in your mind the basic posture at the same time as memorizing two or three key bits of outline.

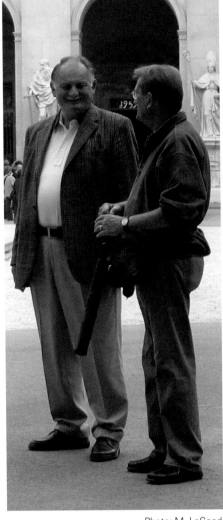
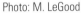

Photo: M. LeGood

I nearly always start at the top, with the lines for the top and back of the head, the chin, the small horizontal for the underside of the nose, and the shirt collar. Those few lines are probably about as many as I can commit to memory from a single glance.

Now look for the narrow, back-to-front C of the ear and the straight lines of his glasses, plus lines establishing his forehead and the front of his face.

With your next glance, catch the lower edge of the first figure's collar, the outward curve of his back and the front of his jacket. Start establishing the position of the second figure by jotting in the slope of his shoulder.

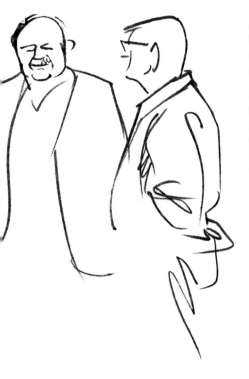

Another quick glance allows you to take in more information about the second man – his head and neck, the other shoulder, the lines of his jacket.

In just a few seconds we've established quite a lot about these two men – their relative sizes, different characters, physical builds, clothing and so on. If they haven't shifted position much, we can get more.

So far every line has represented an edge – but you want your drawing to be more than an outline. The creases and folds in the clothing are important, as they establish the solidity of the figures and give life to your drawing. They're very evident on the first figure's sleeve and around his shoulder, so make sure to note these bold, sweeping lines accordingly. There are similar loose zigzags at the top of his trouser leg. If you don't indicate them, his legs could look like drainpipes.

The complete sketch took less than 15 seconds. It's not something I would plan to show in a gallery, but I think it's lively and, most important, it's going to be informative to me later… and I did it by capturing just a few lines during each of just a few glances.

Practise speed sketching often. The sureness of touch you'll gain will prove invaluable in all your future drawing, whether from life or imagination.

The sketches in this column, taken from another page of my sketchbook, probably represent, all told, about half a minute of drawing time. As you can see, some had to be abandoned pretty quickly when people moved. In other cases I had time for two or three glances.

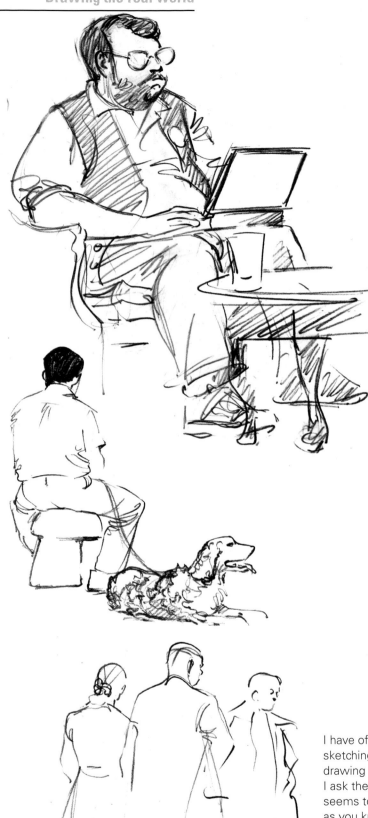

I drew the bearded character with the laptop computer at a science fiction convention in Liverpool, England. All the other sketches were drawn during holidays.

I have often found that new artists shy away from the challenge of sketching people. I've had many students tell me they consider figure drawing from imagination the most difficult skill to accomplish, but, when I ask them why they think so, they're often at a loss to explain. After all, it seems to me that you should be able to draw anything in the world so long as you know what it looks like, but when it comes to drawing people, you know what it feels like to actually be one! Of all drawing subjects, people should be the one you're most comfortable with.

In my book *Figure Drawing Without a Model* (David & Charles, 1992 and subsequent editions), I've written at length on this subject, as it is one that every imaginative illustrator must master. In it I have a lot to say that is both useful and significant for anyone with an ambition to illustrate stories.

Students in an illustration class at l'Ecole Emile Kohl, Lyons. Because I had plenty of time, I was able to focus on creating texture and pattern. I shall deal with this approach to drawing in the next chapter.

The illustrations on this spread and the next are all observation sketches done during practice sessions at a dance school.

Sketching people as they move around may seem a very tall order, but in fact all you need if you're to make a credible attempt at it is a reliable basic strategy.

When you draw anything from observation you ordinarily look at your subject, then refocus on your sketchbook page to draw what you've just seen, then repeat the process as often as necessary or possible. There's only a brief moment between your looking at the subject and looking at the page, but it's perfectly possible to have forgotten some or all of what you've seen of the subject by the time your brain has reconfigured itself to deal with drawing on the page.

The bustle of movement at the beginning of a session in a dance studio might not seem an ideal atmosphere in which to be drawing, but I can heartily recommend it if ever you get the chance! The dedication and commitment shown by the students can be surprisingly inspirational.

It's an experience far more common than you might suppose. To overcome it, try drawing without taking your eyes off the subject. Jot down the whole posture – head, neck, spine, arms, legs – in a few swift lines. If your subject hasn't moved by this time, you can now quickly build the figure on the framework of this structural drawing.

After a few sessions using this approach, you'll find you're able to adopt the procedure outlined on pages 20–21 – keeping the whole posture in mind while you quickly jot down the few specific details you've made it your task to memorize. This will enable you to attain a more eloquent contour while still retaining the drawing's vitality.

All the drawings on this page are reproduced to the same size as my originals. The procedure adopted for these was as demonstrated on pages 20–21.

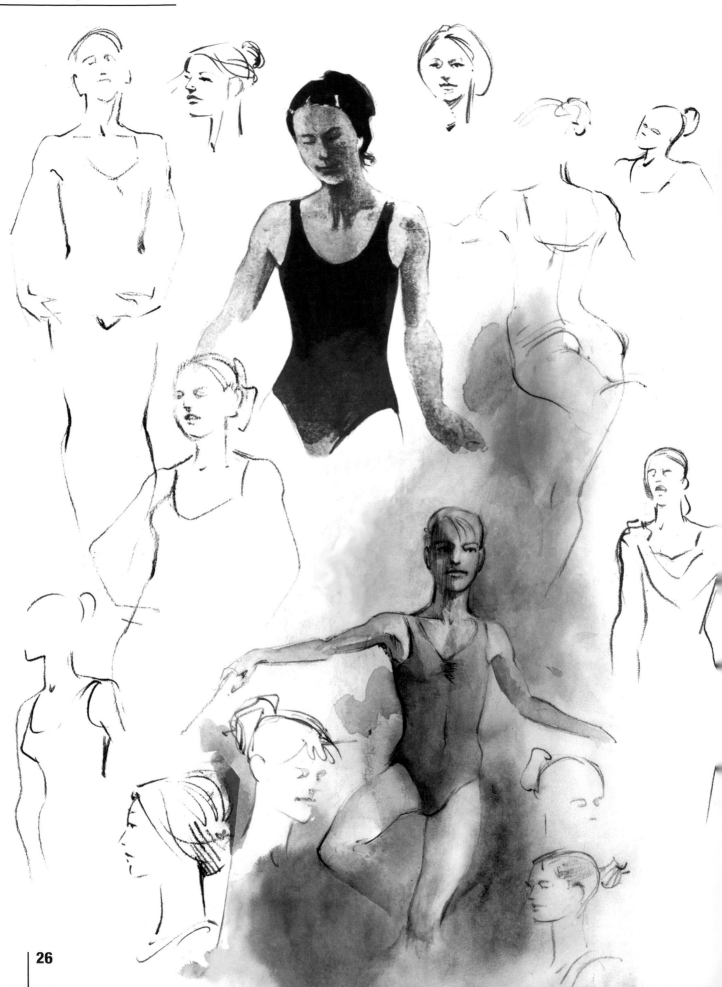

People in motion

When drawing moving figures you need to work very quickly and be willing to abandon each sketch as soon as the subject changes position irrevocably. Many of the drawings on these pages were done in two or three seconds. As indicated on page 20, I usually try to memorize the top of the head, the jawline, the neck and one side of the body in my first glance. If there's time after I've jotted these down, I look for the lines of the shoulders and limbs. The trick is to stamp onto your mind an impression of the whole posture while committing to memory, in each glance, just the few specific lines you want.

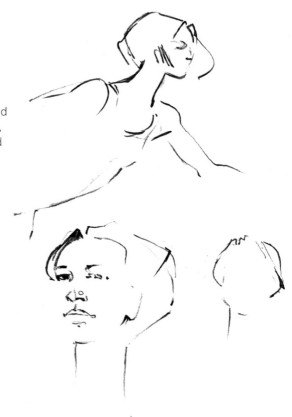

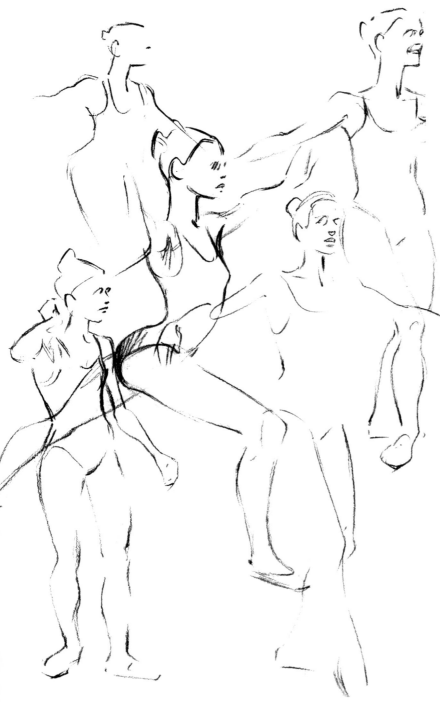

Later is the time to turn your speed sketches into something more, if you wish to, as I've done with a couple of the figures opposite.

It's a high-pressure task, but in my experience it's one of the quickest, most effective and most reliable ways to develop a sure touch and a fertile visual imagination. The constant use of your sketchbook, drawing anything and everything you see, will ensure the rapid development of the skills you need to do it successfully.

More uses for sketchbook images

The basic purpose of the sketchbook habit is to establish a firm link between hand, eye and mind, and in so doing to develop your drawing skills. Clearly, though, there's an extra bonus. You build an archive that will be invaluable as a research tool when you come to create imaginative illustrations. On these two pages are a few illustrations I've done over the years that have relied particularly heavily on drawings, also shown here, that I've unearthed from my sketchbooks. I've deliberately chosen pictures whose debt to the original is obvious.

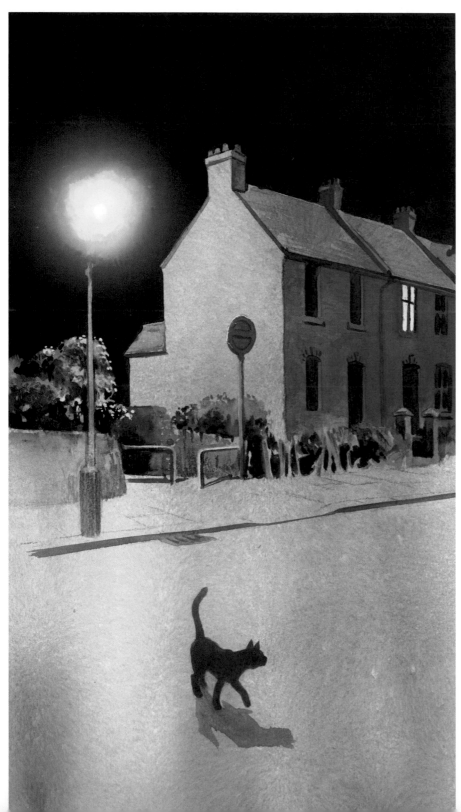

A further advantage of carrying your sketchbook at all times and drawing whatever you see is that you'll find yourself developing a better visual memory, and a progressively greater facility for creating imaginary scenes. This comes about because, by observing and drawing your real world, you will begin to *think visually*, and so lay the ground for later creations of new worlds from your imagination. Obviously, if you've sketched a hundred street scenes from observation, you will find it a simple matter to create a convincing street scene from your head.

Don't underestimate the enormous value of the sketchbook: it offers a key that will unlock your imagination.

This unassuming little sketch of a row of suburban terraced houses has served in a number of illustrations, such as the unpublished colour piece to the left, *Night Cat.*

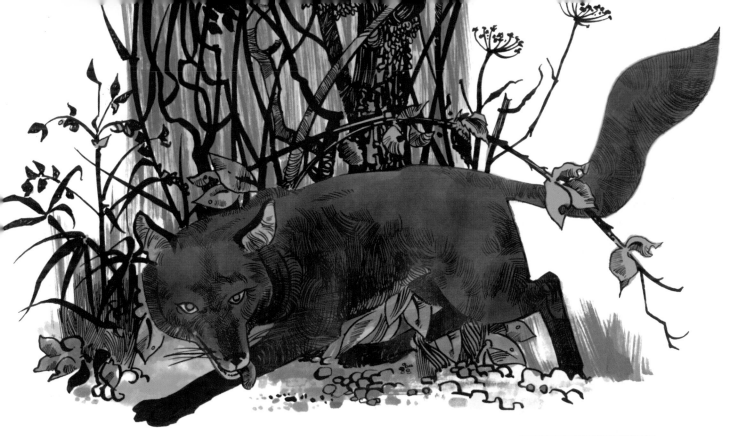

The small sketch at the top right of the opposite page was used as a basis for the rather stylized backdrop of the vignette above.

A frame from a comic strip about a fox. Those houses again!

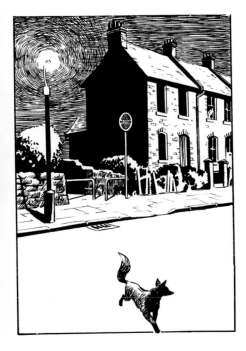

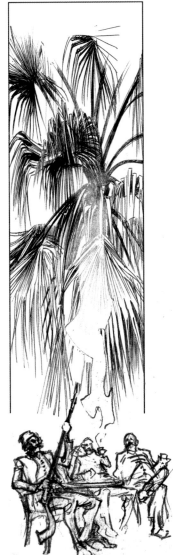

I drew this study of a tropical tree using a ballpoint pen as I sat at a café table in Spain, drinking coffee. Later I used it as a backdrop for a frame in the graphic novel *Maiwand*.

Visual editing

In Chapter One, we saw the importance of the sketchbook in the development of a visual imagination. The habit of carrying a sketchbook with you wherever you go, and drawing anything and everything you see, not only hones your skills, but also helps to forge a firm link between hand, eye and mind.

I suggested that you focus first on getting an accurate record of what you see, because the clarity with which you see the real world will be a measure of how creatively you will draw it. Now we can begin the process of consciously involving your imagination in the act of drawing.

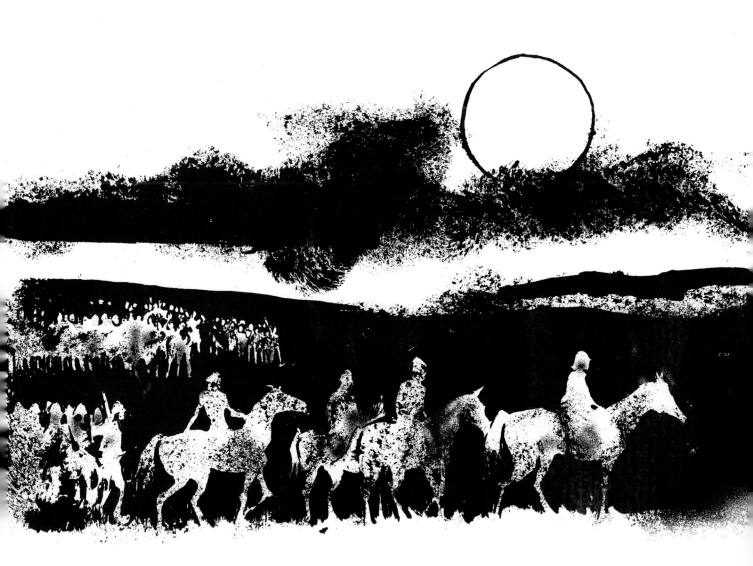

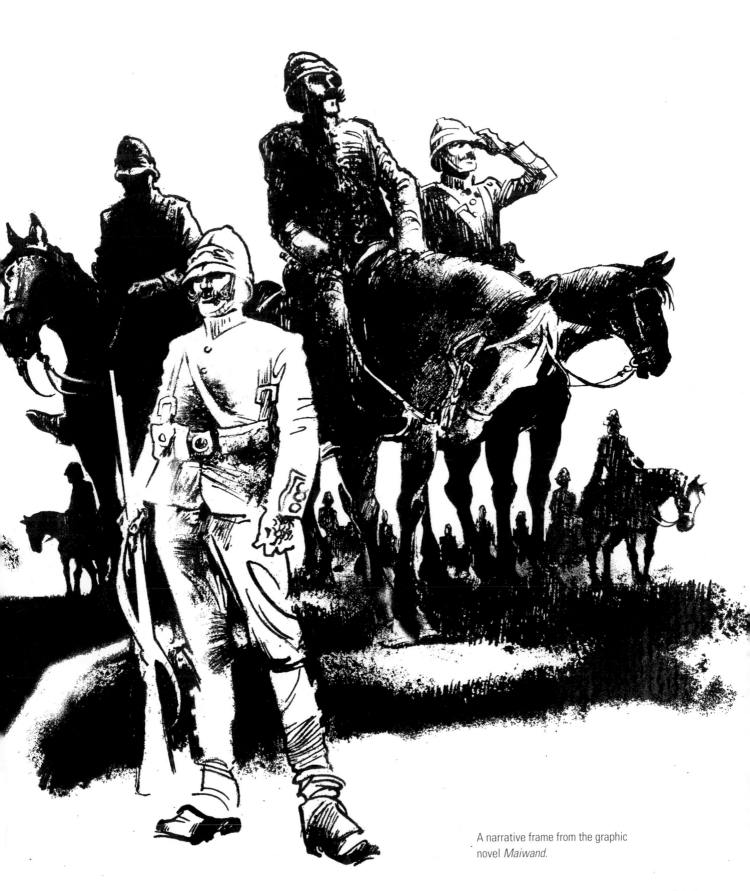

A narrative frame from the graphic
novel *Maiwand*.

If you look at the drawing on this page, you may notice that I've focused my attention exclusively on the delicate fronds of the plant, and by the simple expedient of ignoring all the surrounding details, I've been able to emphasize the delicacy of those fragile curves. If I'd included the chair and table that, in real life, I could see behind the plant, the drawing could all too easily have become a confusion of lines and shapes, and the plant's distinctive elegance would have been obscured. So I simply edited the background out.

To emphasize the elegant shapes of the tropical plant, I edited out the intrusive lines of the furniture I could see behind it.

Of course, this is something everyone does when they begin drawing: they focus on one object and ignore everything else around it.

But in this drawing I've done more editing than simply eliminating the background. To achieve a reasonable simulation of the glossiness of the plant's leaves, I could have used charcoal on a smooth paper and then smudged it with my thumb. Instead, I drew fine radiating line patterns on the leaves to create the illusion of shimmering light. That's not what I saw there. I chose to edit reality.

This wasn't my intention at the outset. I started to draw the plant simply because I liked the shape of it. I added the hatching to the fronds when I found that a simple outline wasn't enough.

The drawing is an edited version of reality and, in a sense, is more evocative because of it.

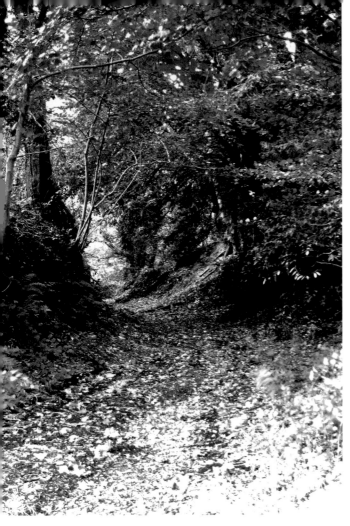
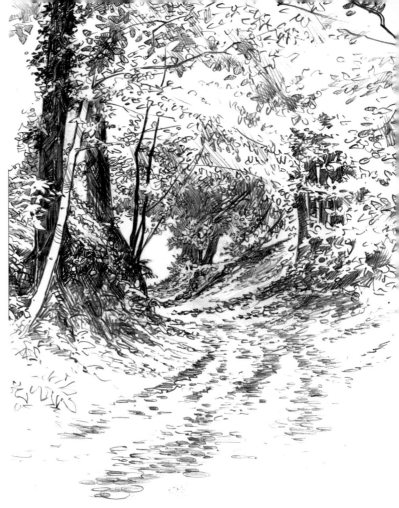

Above – Trees in full leaf are among the most difficult subjects to draw from observation: there's so much to consider. The task seems gargantuan until you realize that drawing involves a process of interpretation and selection – editing, in other words.

Below – By editing out the area to the left, this drawing focuses attention on the rocky stream.

Drawing *anything* from observation involves a process of selection. Just as we wouldn't expect a piece of music representing a babbling brook to actually sound like an audio recording of a real brook, so we will not necessarily aim to make drawings that look like photographs.

I was going to show a fastidiously accurate drawing of a woodland scene at the top of this page in order to demonstrate what I mean, but about halfway through doing it I got bored and decided to use a photograph instead. I'm happy to produce meticulously detailed drawings from my imagination, but if it's a matter of slavishly copying something it isn't long before my patience and commitment desert me!

What the photograph shows is what the eye would see: every detail. In practice, though, even if you were standing in the middle of this forest lane you wouldn't observe the scene like this. Your brain would edit the information coming in from your eyes, focusing on various interesting features in turn, perceiving the remainder as a sort of coloured blur surrounding the items in clear focus. Your job as an artist is not to give your audience a slice of real life, undigested, but rather to present an aspect of our *experience* of the world in an organized, structured form. You can see in the drawing alongside the photograph how I've edited the outlines and shadow areas to make the end result more satisfying – more *real*.

Visual editing is something we do all the time, usually without thinking about it. In the rest of this chapter we'll look at how we can turn this editing process into a more conscious procedure, one that involves the imagination.

This kind of thoughtful drawing – playing with pattern and texture, outlines and the shapes of shadows and light areas – involves the creative imagination in the act of drawing, and quickly leads to a growing inventiveness in the work you produce. Your drawings will gain a greater depth because now they 'have something to say'.

There are other benefits, too. You'll find yourself becoming more keenly aware of shapes and patterns, and of the ways in which a drawing can emphasize certain aspects of what you see – in other words, you'll start developing a heightened awareness of the visual world around you, and of how drawings can speak directly to people's emotions.

That sounds a pretty grandiose aim! But I'm not trying to say that every drawing you produce should be capable of moving its audience to tears. There's a certain lift of the spirits people feel when they see a drawing that has something special about it. It's that distinctiveness you should be aiming for.

Left – When we're seeking out visually fascinating shapes and patterns, no subject is too humble for consideration. I made this drawing of a brand-new spotlight bolted onto a weatherbeaten lookout tower during a holiday in Spain.

Left and above – These two drawings show how little visual information is needed to make a satisfying and recognizable portrait, but that is not the main point here. We are concerned with the pleasing arrangement of shapes on the page, and by fragmenting these shapes in interesting ways, the drawing is rendered more lively and arresting.

Below – These three sketches were deliberate attempts to isolate objects which, despite their seeming insignificance, could offer enticing patterns and shapes.

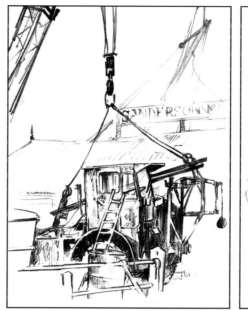

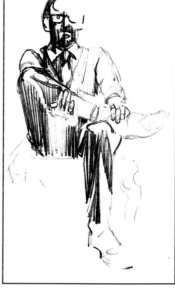

Above – Two drawings of everyday subjects, drawn in a way that emphasizes and isolates the patterns of the shadows.

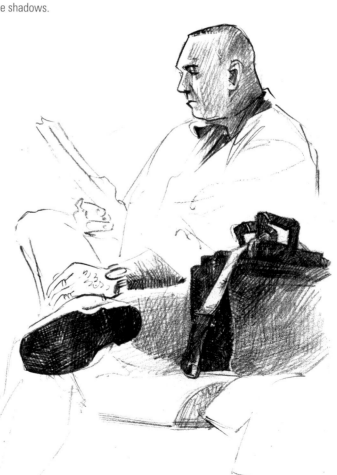

Right – This sketch of a businessman was done in an airport lounge. With its interesting combination of simple outline and areas of fine detail, it is, I suppose you could say, an example of editing by default!

So far it might seem as if I am recommending an editing process that is merely a matter of leaving stuff out – of subtracting visual information from what you actually see. But visual editing is far more – and far more interesting – than that. What it's concerned with is enhancing the effect on the viewer of the shapes, lines and patterns in the finished drawing. By taking this approach to every visual image we create, we give a boost to our own creative thinking.

I did the sketch to the right during a conference I was attending. My aim was to make attractive patterns out of the shapes of light and dark on the figure. It isn't a piece of finished artwork, just an exercise in creating interesting patterns and textures within what is ostensibly a realistic depiction of a mundane subject.

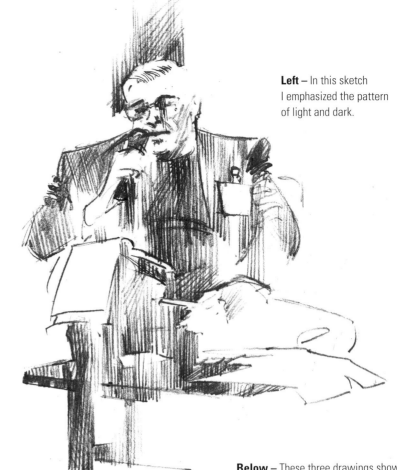

Left – In this sketch I emphasized the pattern of light and dark.

Below – These three drawings show how editing what you see can help to create an effectively evocative final drawing.

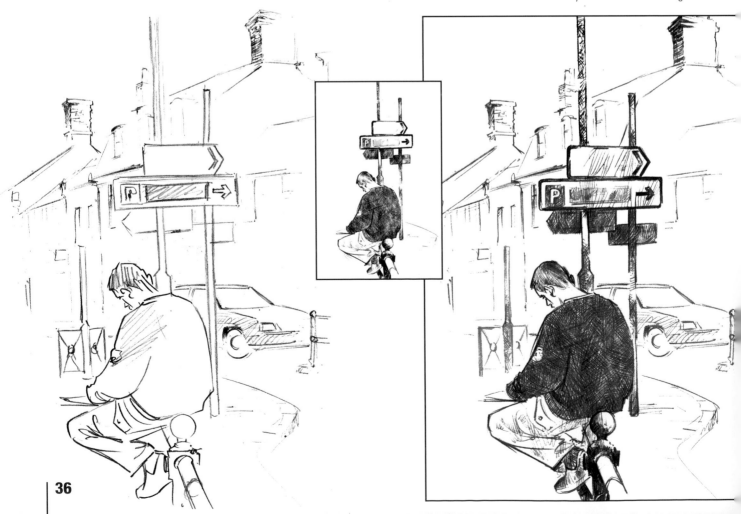

Left – A perfectly adequate drawing of a woman walking her dog. As we can see even more clearly in the silhouette version beside it, though, the image makes a pretty dull shape.

Above – Giving the image a more interesting shape on the page makes for a more lively and arresting version. Even the silhouette has life and movement the earlier version lacks.

Along the bottom of the opposite page you can see, first of all, a drawing I did of one of my students while he was sketching in the street, and then two further drawings I developed from the first, enhancing the patterns and textures of the main shapes to make the image more interesting – more arresting in the way it attracts and intrigues the eye.

The illustrations on this page represent a similar process, showing how you might go about creating an illustration of a woman walking her dog. The first sketch fulfils the basic requirements: it contains a woman and a dog and, yes, they're walking. But almost certainly you'd want to make the image a bit more forceful and dynamic. One way in which to achieve this is to make the arrangement of shapes on the page livelier. Of course, it's not the only change I made in the later versions, but look at the two silhouettes to see how, even on its own, the second makes for a more arresting illustration.

Right – When I was creating the final version I decided to alter the angle of the woman's head. With hindsight, I think that was an error of judgement.

Generally speaking, both in on-the-spot sketching and in creating pictures from our imagination, we will usually want to select a viewpoint that gives the clearest and most effective image, so that no one will feel they have to puzzle out what the picture is about.

At the top left of the page opposite is a colour rough I did for an illustration of an incident during the famous 17th-century witch trials in Salem, Massachusetts. According to the brief I was given by the publishers, Pearson Education, when one old woman was found guilty of the charge of witchcraft she turned to her accuser and said, 'I have never in my life cursed anyone! But now I lay this curse upon you – that you will die within the year, and that your ghost will walk the earth for eternity!'

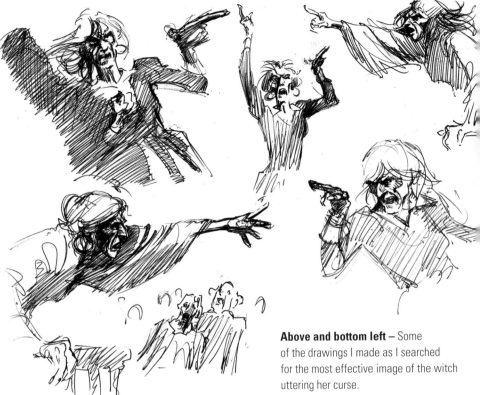

Above and bottom left – Some of the drawings I made as I searched for the most effective image of the witch uttering her curse.

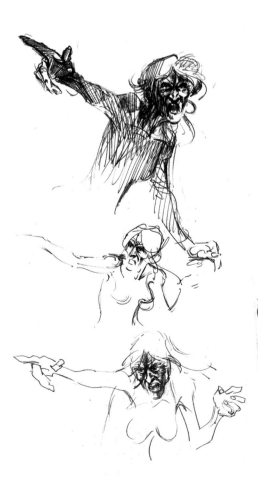

Above – The composition rough that I sent to the publisher for approval. I took a low viewpoint looking up at the witch to add drama to the illustration.

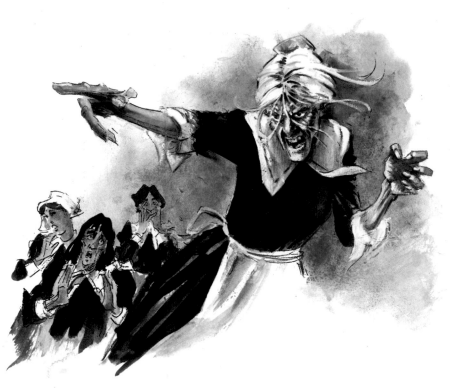

Left – The colour rough for my illustration of the Salem woman accused of being a witch.

I needed a forceful and arresting image of the woman uttering her curse, and the drawings on the left-hand page show my search for just the right posture and viewpoint that would give the incident the drama it needed. The same principles are at work here as in the example on page 37 of the woman walking her dog.

The bottom half of this page shows a similar searching process, this time in the development of an illustration for John Grant's novel *The Far-Enough Window* (BeWrite Books, 2002). For this image I sought to convey a sense of magic. I did it in part by emphasizing the effect of the light.

Below left – Some of my preliminary ballpoint drawings for an illustration of the traditional fairy figure Robin Goodfellow.

Above right – The final illustration as it appeared in *The Far-Enough Window*. I created the freckled textures by dabbing the page with an inky sponge.

Below – The effect of this illustration for a children's retelling of *Dr Jekyll and Mr Hyde* (Usborne, 1995) is greatly enhanced by the white palm fronds, which break up the dark shape of the suit.

Above – The interrupted outlines, and the minimal treatment given to the clothing of the left-hand figure, help to give movement and life to this preliminary drawing for a frame in the graphic novel *Maiwand*.

Below – This small priest-like figure is a single component from the large, complex composition on page 125 that made up a page of a graphic novel.

Above – A humorous figure from the graphic-narrative book *Ten Minutes*. The deliberately ragged linework combines with the ink splashes and blots to give the illustration an anarchic spontaneity.

Editing in practice

The pictures on this spread show various examples of the editing process put into practice. In some I have omitted outlines and contours. In a couple I have added a rectangular image to enhance the shape of the picture as a whole, and so on. In each case I gave careful consideration to the overall design and to the patterns and textures that would attract the viewer's eye and make a strong impact.

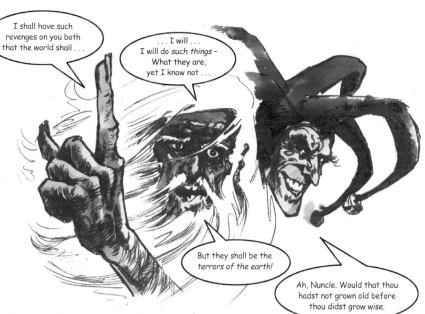

I shall have such revenges on you both that the world shall . . .

. . . I will . . . I will do *such things* – What they are, yet I know not . . .

But they shall be the terrors of the earth!

Ah, Nuncle. Would that thou hadst not grown old before thou didst grow wise.

Above – A frame from a graphic-novel version of *King Lear*. In cases like this, when working out your composition it's not just the pictorial elements that need to be considered as important shapes in the composition but also the speech balloons.

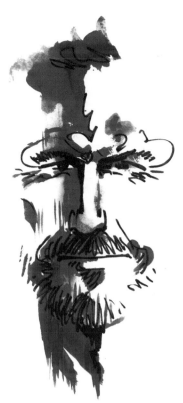

Above – A quick self-portrait that I decided looked better left unfinished!

Above – An illustration in 'church window' style from a book about monastery life: *In a Monastery Garden* by E. and R. Peplow (David & Charles, 1989).

Left and right – Two frames from the graphic novel *Maiwand*. In graphic narratives you need to leave plenty of space for lettering.

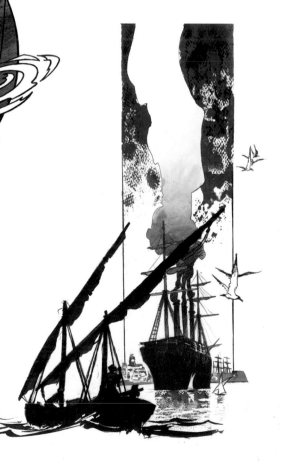

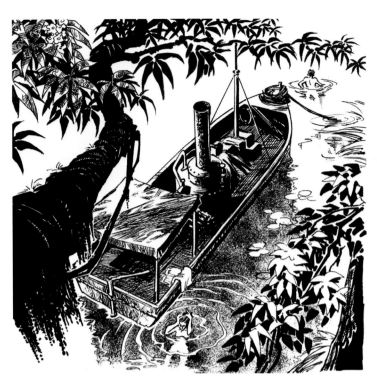

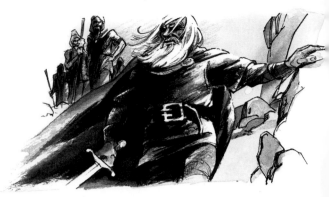

Above – Illustration for the Anglo-Saxon poem *Beowulf*.

Left – I enhanced the rather dull-looking boat in this illustration for Oxford University Press's 2004 edition of C.S. Forester's *The African Queen* (1935) by creating a pattern of shadows on its deck and a frame of tropical foliage.

Below – In this illustration for a comic-strip adaptation of Captain W.E. Johns's *Biggles* I gave the dark undersides of the wings and the criss-cross pattern of the struts a texture of broken colour in order to add to the picture's appeal.

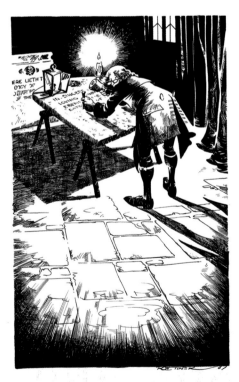

Above – An illustration for Smith Settle's 1987 edition of Sabine Baring-Gould's *Yorkshire Oddities* (1874), showing the Wakefield parish clerk Peter Priestly.

Editing more complex illustrations

Compositions that include multiple elements (such as groups of figures and objects) and large masses (such as buildings and ships) offer you great opportunities to merge and combine big shapes into decorative areas of light and shadow. Even so, it's important to remember that fine authentic detail remains important. We don't merge masses of shadow into one another simply to avoid having to draw them properly; we do it to enhance the effect of the finished picture. To show what I mean, on the far side of the opposite page I've set one of my preliminary working drawings above the final version of my picture of a dockside scene.

Above – An illustration for OUP's 1998 edition of John Buchan's *The Thirty-Nine Steps* (1915).

Below – Cover illustration for an issue of a Sherlock Holmes Society journal. I carefully grouped the two figures and the hansom cab in order to achieve an evocative vignette composition.

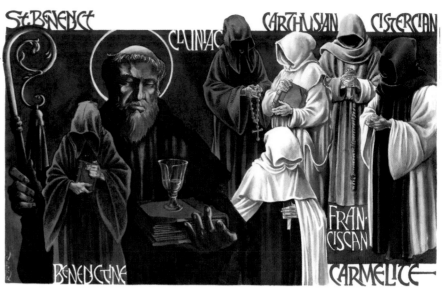

Above – In this illustration for *In a Monastery Garden* the 'antique' lettering gives interest to what could otherwise be a dull rectangular shape.

Comparing the small reproduction of one of my preliminary drawings (**right**) with the finished picture (**below**) shows the extent to which forms and shadow areas were merged to create the deep blue area in the centre of the image. This illustration was done for Helen Brooke's *Mystery in London* (OUP 1999).

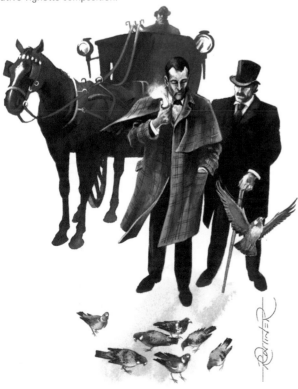

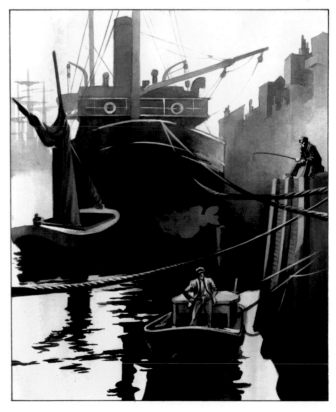

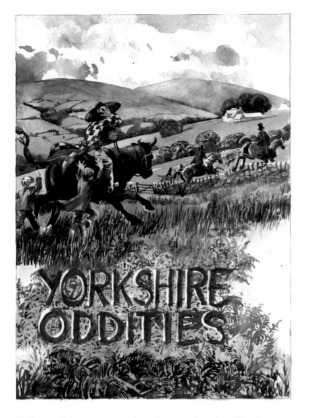

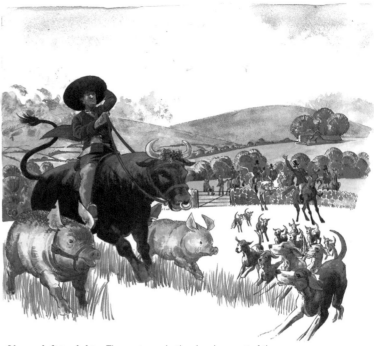

Above, left to right – Three stages in the development of the cover illustration for Sabine Baring-Gould's *Yorkshire Oddities*.

Below – This illustration, done for the educational book *Literacy Through Texts Book 3* (Pearson Education, 2003), shows Marlowe's Doctor Faustus as he contemplates selling his soul to the Devil for 25 years of absolute power.

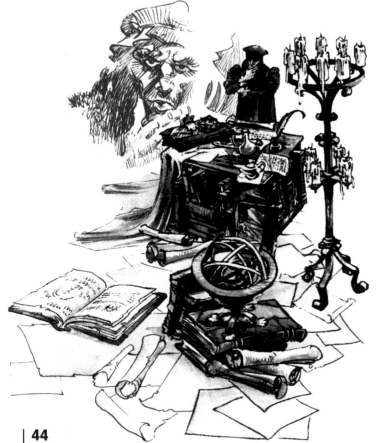

Merging and combining background details

Objects and location features can be merged and combined into effective groupings and patterns of light and dark for maximum effect – as exemplified by the illustrations shown on these two pages. This is where the great value of sketchbook practice, drawing from life such mundane-seeming subjects as a pile of dirty dishes, reveals its enormous value. Had I not done sketches like that one of the pile of unwashed dishes (page 14), I'm sure I wouldn't have been able to make such a creditable job of arranging the books, manuscripts and archaic objects in the Doctor Faustus illustration shown here!

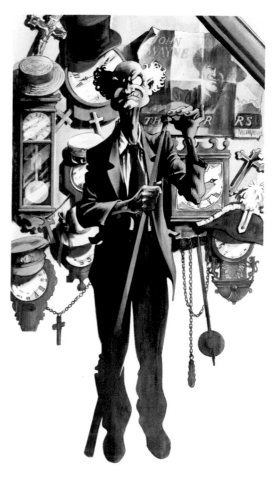

Left – A pen and ink illustration I did for a 2001 educational book entitled *Spook City*.

Below – Judicious placing of dark masses and white shapes contributes to the success of this frame for the graphic-narrative book *The Pickle at Trafalgar* (Perretti, 2005).

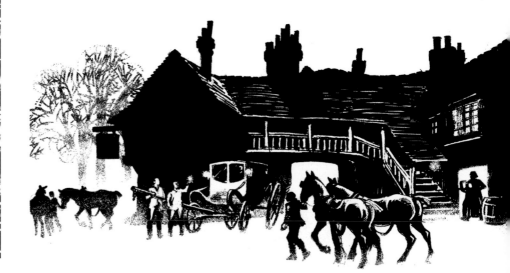

The birth of a story illustration

The illustration here was done for Tony Allan's children's book *Tales of Robin Hood* (Usborne, 1995) to depict the interruption of the marriage of Robin and Marian by the Sheriff of Nottingham's soldiers. Initially I chose a high viewpoint, looking down on the scene. However, the publisher felt this wasn't forceful enough, so I shifted the focus to concentrate on the soldiers.

I decided that if I could place the minor figures against the light coming in through the doorway I could simplify the figures at the rear of the church into flat patterns of coloured shadow.

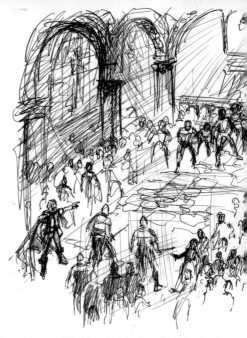

Above – Working sketch of my first idea for the scene, looking down from on high as the soldiers move from the bottom left foreground towards the wedding party. This could have been quite an arresting illustration in its own right, with the figures grouped into massed shapes, but the art editor wasn't so keen. Back to the drawing board.

Far left – This first sketch of the second version was okay, but I felt that the main figure needed to dominate more – the soldiers are all about the same size and don't look interesting. The solution was to have him pointing aggressively towards the reader.

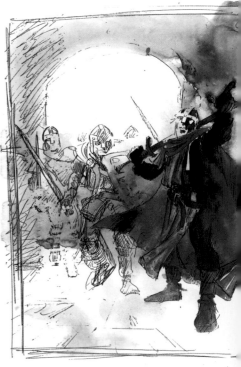

Above and left – Drawings I did to explore postures and body language.
Right – The colour rough.
Opposite – Finished artwork for the illustration, which in *Tales of Robin Hood* is captioned: 'Stop the wedding! Robert of Locksley, you're a traitor!' I painted the doorway and background figures in watery transparent colour first, then used stronger colour for the central soldier. Finally, working in more detail and contrast, I painted the dominant pointing figure.

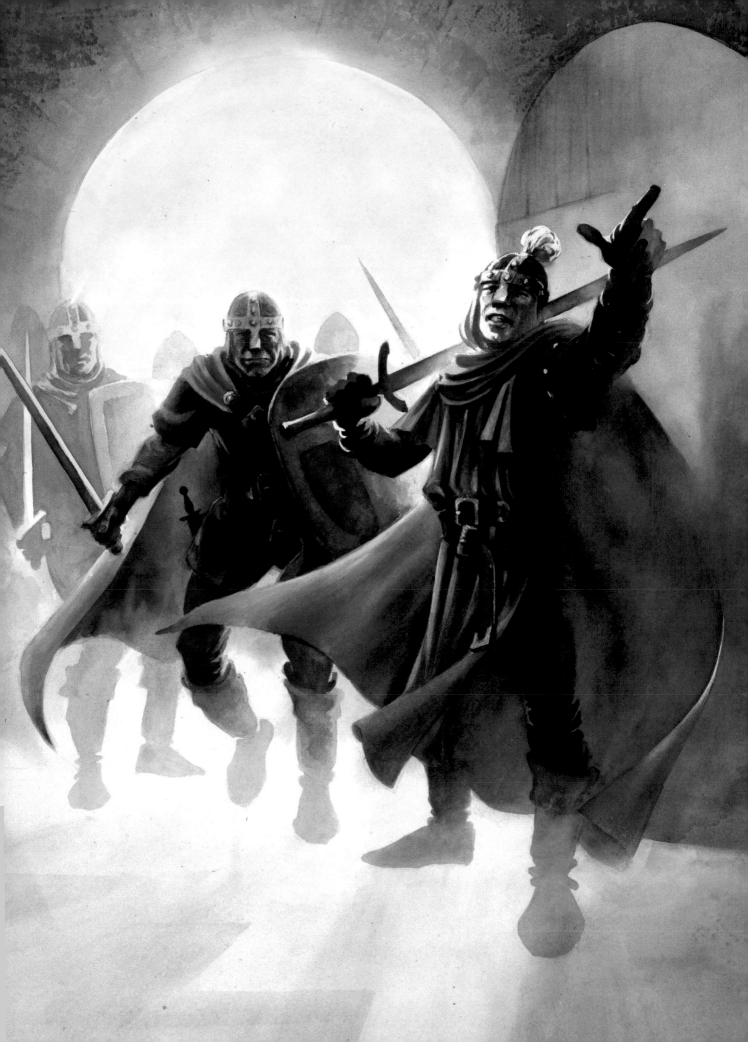

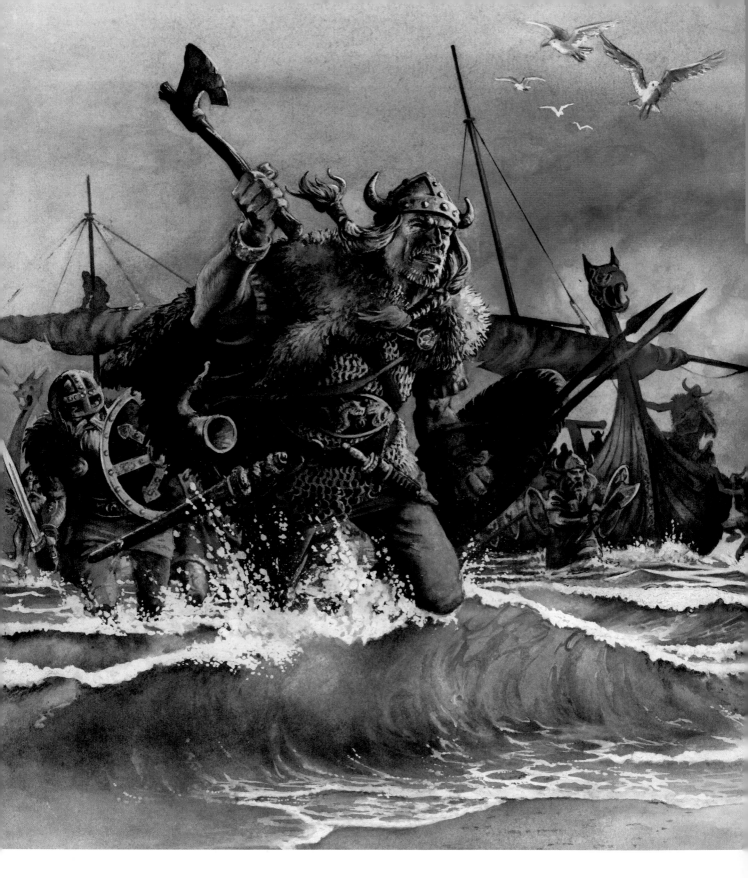

Unpublished — until now — painting of invading Vikings.
Once I had finalized the composition I drew it in pencil
on illustration board. Next I laid in the sky and the sunset using
thin transparent washes of gouache. Then I painted the ships
and background figures, and finally I did the foreground figures
in greater detail using opaque colour.

History-book illustration

Creating illustrations for educational publications is a very demanding job, but can also be a relatively well paid one. You need to do a lot of research because, although educational publishers typically give you a fairly complete brief, and should have experts on hand to check your roughs and final artwork for authenticity, it can be tedious and time-consuming if you keep having to make corrections.

This painting of a Viking invasion was not done for a publisher, though. When the British comics industry collapsed in the early 1980s, I needed to look for work in new areas and produced this sampler for publicity purposes.

Many people have since told me that Vikings didn't have horned hats. Well, I'm not aware the Vikings were sticklers for uniform, either, so it's feasible that some of them wore horns like these. Isn't it? Well . . . This is the kind of consideration that might have seen me making extensive revisions had the picture been a commission.

Below – A silhouette diagram isolating the three basic shapes involved in the composition. As you can see, even though this is a more complex illustration the principles are the same as when creating the picture of someone walking her dog (see page 37).

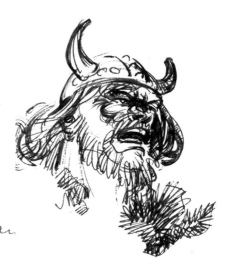

Shown on this page are some of the preliminary drawings and roughs I did as I searched for the most effective composition.

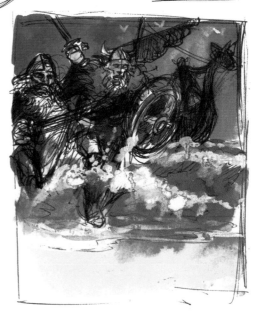

Positive and negative shapes

While you're editing to find the most effective shapes and patterns, you'll sometimes realize that what you *don't* draw may be as important as what you do draw, or even more so! When you look at the well-known old cliché to the right here, you might see either a vase or two faces. What I drew was the vase, of course. The 'faces' are only the spaces to either side of it.

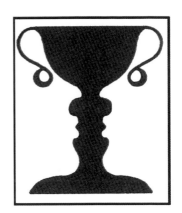

Left – The plant in the foreground of this illustration for a children's retelling of *Dr Jekyll and Mr Hyde* is really a plant-shaped hole in the man's dark jacket. I used the same tactic in another illustration for that story (see page 40).

Below – An illustration done for OUP's 1997 retelling of Joseph Conrad's *Lord Jim* (1900).

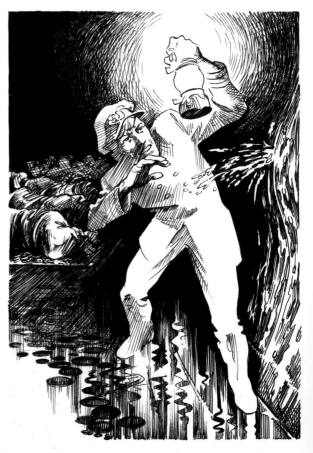

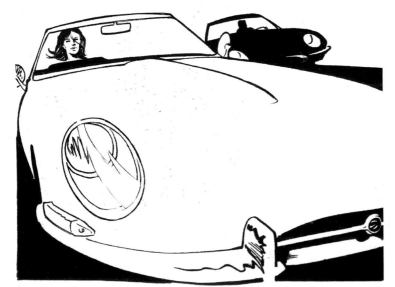

Left – I drew very little for this illustration of two E-type Jaguars. Most of it is made up of negative shapes.

Right – For this page for a graphic novel, I drew successive narrative frames as positive and negative shapes in order to avoid producing what could have been a cluttered and unreadable page.

We refer to the shapes we actually draw as positive, and to the spaces around and between them as negative. One very astute commentator once put it this way: 'A tree is normally seen as a solid in space, but an artist may consciously invert the world and see it as a tree-shaped hole in the air.' The illustration on pages 30–31 is an example of my doing this. The horses in the background are really 'horse-shaped holes in the air'!

In the examples on this spread I consciously made use of negative shapes to increase the effectiveness of the drawing and/or to offer the viewer additional visual information.

The more sensitive we become to the way patterns of light and dark can give liveliness and interest to our drawings, the more satisfying and evocative our pictures are likely to be.

Below – For the image on the left I digitally reversed the positive and negative shapes of another of the illustrations from the *Jekyll and Hyde* retelling. You can see how the liveliness of the composition depends on control of the white and black areas.

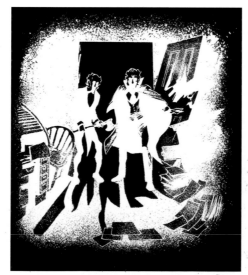

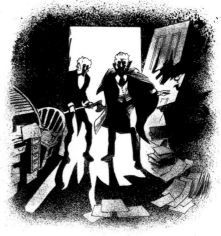

The human figure

The human figure is at once the most challenging and the most rewarding of subjects for the imaginative artist. It's often been said that if you can draw people, you can draw anything. Moreover, when you're drawing people you're drawing not just what you see but what you are – a human being! – so you have some understanding of what's going on behind the exterior a person presents to the world.

I touched on the subject of figure sketching in Chapter One (see pages 18–27). Here we'll look more closely at this eternally fascinating subject.

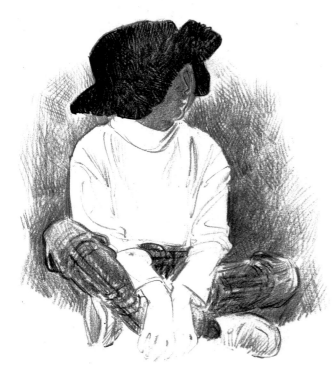

The illustrations on this page are: a frame from a graphic-novel version of *The 1001 Nights* (**top right**); a colour sketch of my granddaughter (**above**); working drawings towards an illustration for a children's retelling of Joseph Conrad's *Lord Jim* (**above right**); and an illustration for Alfred Noyes' poem 'The Highwayman' (**right**).

The illustrations on this page are (**clockwise from top left**): part of the cover artwork for John Grant's novel *The Far-Enough Window*; a rough colour drawing of Sherlock Holmes; part of an illustration for Tony Allan's *Tales of Robin Hood*; a preparatory sketch for a picture of King Arthur; and a pencil study from life of a nude model.

Drawing from a posed model

You probably won't have too much difficulty finding a family member or friend who's prepared to pose for you, although if you take more than about half an hour over your drawing the chances are your volunteer will become restive.

Some people seem to have a natural understanding of what kind of pose makes for a good drawing, and can hold it at least reasonably well until you've finished. Others are quite the opposite – they move around, chatting animatedly, apparently without any conception that you need them to keep still. (I've even had a volunteer model turn her back on me!) Of course, when you're not paying your model anything, you have to keep your irritation in check.

At first, it's probably best to stick to line drawing, seeking out the shapes and lines of the clothing to help you get the proportions right.

Right – All but one of the drawings on these pages are of friends or family members, who didn't need to be paid! A casual standing pose such as this is easy for a model to hold.

Below – I did these little drawings when my niece, then 14 years old, was watching television. As long as there is something external to hold their interest, most people are willing to keep still long enough for you to make a quite detailed study drawing.

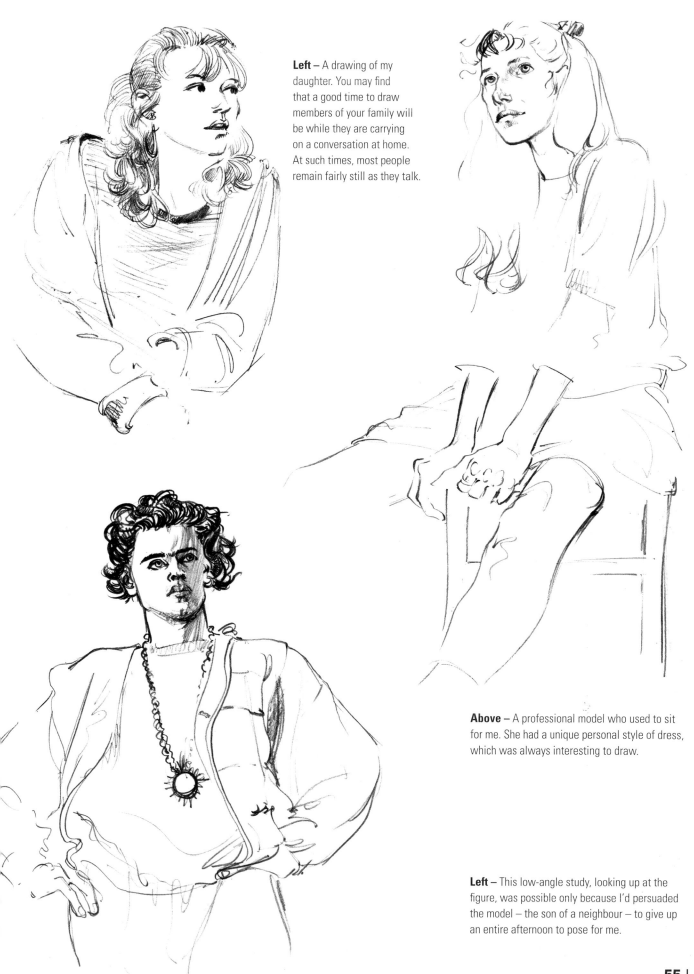

Left – A drawing of my daughter. You may find that a good time to draw members of your family will be while they are carrying on a conversation at home. At such times, most people remain fairly still as they talk.

Above – A professional model who used to sit for me. She had a unique personal style of dress, which was always interesting to draw.

Left – This low-angle study, looking up at the figure, was possible only because I'd persuaded the model – the son of a neighbour – to give up an entire afternoon to pose for me.

If you want to do more than a simple line drawing, you'll need to find a model who's prepared to be patient and cooperative. Seeking out areas of shadow and pattern takes time; while it may not seem long to you, deeply immersed as you are in the pleasurable act of drawing, to your model the duration can seem interminable. Try placing a television set so that the model can watch it to relieve the monotony.

Right – Like this drawing of my wife, all the drawings on this page were done with a B or 2B pencil. The models were positioned for the best effect of light and shadow.

Left – My granddaughter was 15 at the time of this drawing. I used a series of vertical lines to establish the light and dark tones.

Right – Sallie, a model who has posed for me hundreds of times.

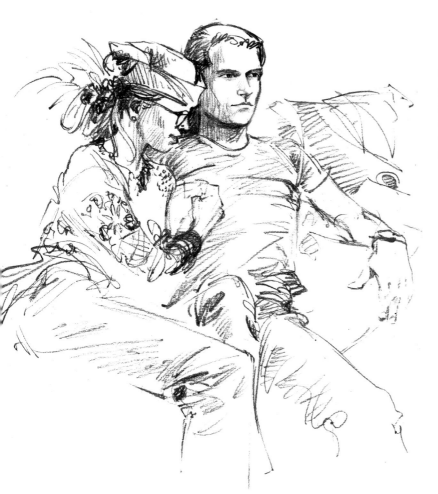

When you're trying to draw a group of two or more (**left**), it takes much longer to do the subject justice. Remember, time may seem to flit by for you yet drag interminably for your subjects. As a last resort, you may find you're reduced to using yourself as a model (**below**).

Left – A portrait study I did of my daughter when she was 16.

Right – Luckily, my granddaughter has always been willing to pose for a drawing. This, done when she was five years old, is one of hundreds I've made of her.

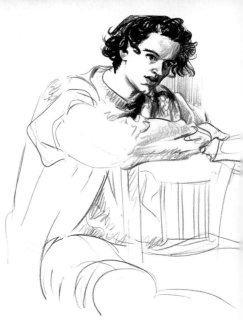

Colour

If you intend to work in colour, you need to find a model who's prepared to set aside an hour or two – perhaps even longer – simply to stay still and look interesting. There's not much point in the endeavour otherwise. If you find you're being obliged to work in haste or finish hurriedly, you're not likely to be getting as much value as you should from the exercise. And there's the added problem that if it doesn't turn out to be a masterpiece, it can be embarrassing as well.

Right – Try starting with a simple line drawing, then adding tonal values in a single hue using watercolour or diluted ink.

Above – Coloured pencils are an attractive medium for life drawing. Start by drawing in outline, selecting a suitable colour for each item of clothing, increasing the range of colours as you add shadow and pattern.

Opposite – This painting of my granddaughter began life as a fairly detailed line study in my sketchbook. I printed an enlarged copy of that study onto an A3 (43 x 29cm/17in x 11½in) sheet of heavy watercolour paper, and added colour to that.

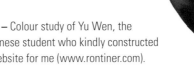

Right – Colour study of Yu Wen, the Taiwanese student who kindly constructed my website for me (www.rontiner.com).

Above – Another drawing of my granddaughter to which I added colour later. It's important always to establish the light source first. Having the model to hand and willing to readopt the pose if necessary is extremely useful.

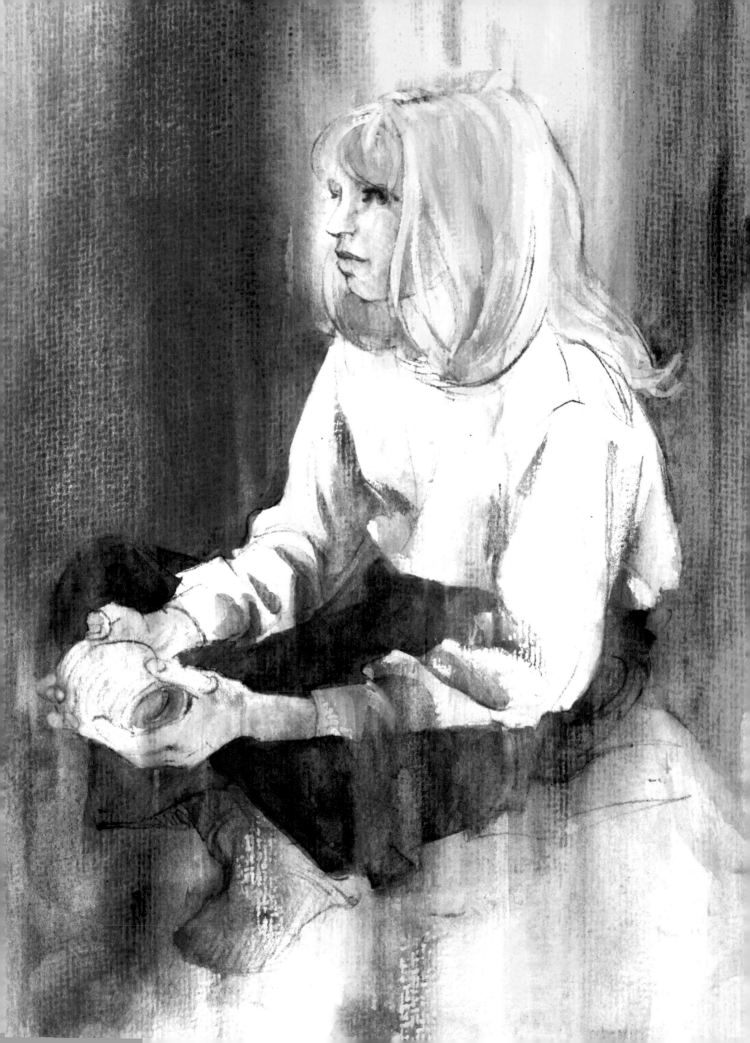

Drawing the nude figure

Life drawing from a nude model is an absolutely essential discipline for any serious-minded figurative artist – including the imaginative artist, who needs a thorough knowledge of anatomy in order to create convincing human figures. Life drawing is an exercise that goes to the very roots of basic drawing practice, which is why every responsible art college includes it in the basic curriculum.

Good models are difficult to find. Your model needs to have a distinct awareness of the shapes they make in the air, and to be strong and physically flexible enough to offer a wide range of movements and postures. All the drawings on these two pages are of the same model, whose natural grace and ideal proportions made her the best model I've ever used. By contrast, I've known art colleges who have been unable to find models capable of posing in more than three basic positions – standing, sitting and lying down.

If you can't afford modelling fees, and can't persuade a friend or family member to strip off and pose for you, try to find out if there's an evening class in life drawing available. If all else fails, obtain a large mirror and draw yourself.

The best idea at first is probably just to draw what you see in outline. If you've followed the advice in Chapter One about sketching from observation, you already know many of the basics about drawing a model.

All the drawings on this page were done when the model was 'at rest'. This particular model often unintentionally adopted very useful poses, needing little or no positioning from me.

Above and below –
Many people who offer
themselves as models can't
adopt positions like these,
let alone hold them long
enough for you to make
a drawing or painting.

Poses like these help you gain familiarity with
musculature and joint structure, plus a clear
understanding of how the human body works.

Intensive study of the nude is the most valuable
exercise there is to increase your drawing skill
and improve your visual memory and imagination.

Drawing a model in a studio is a far less frenetic activity than sketching people
in public places, and you may well find the visual editing process we talked about
in Chapter Two (see pages 30–51) becomes a natural part of your thinking as you
work in the calm atmosphere of the life room. In other words, at some point as you
draw you may decide you want to concentrate on the requirements of the drawing
as an art object at the expense of making an exact record of what you're seeing.
You may decide to emphasize the effect of light on the figure, or limit yourself
entirely to a fine outline, or edit the shapes, patterns and lines of your drawing
in other ways – whatever the impulse, go with it. Experimentation, even if
unsuccessful, can only add to the value of life drawing.

Achieving good draughtsmanship skills is not
easy, and there are no short cuts. However, the
journey is a fascinating one. This is a learning
experience that will last the rest of your life.

Bear in mind as you draw that your model is a creature very similar in every way to yourself. While you study and record the shape and structure of shoulder, wrist, hip, knee and so on, be aware of these joints in your own body.

By keeping yourself aware of your own body you'll build skill based on understanding rather than on superficial tricks.

The human body is one of the most versatile living structures in nature, and certainly among the most fascinating. There is no area of study more valuable to the imaginative illustrator.

Above – I executed this standing figure using diluted inks, emphasizing subtle gradations of tone to reveal surface form.

The nude in colour

On these two pages you'll find several approaches to using colour in your drawings and paintings of the nude. Don't think of them as clever tricks to get you by, though; rather, regard them as examples of lighthearted play. If you want to achieve success as an imaginative illustrator, you'll soon realize there are no shortcutting alternatives in life drawing to the necessary hard work and study.

This is not the place for a detailed discussion of painting the nude, traditionally the most important part of an artist's training. There are plenty of books on the subject, so read as many good ones as you can lay hands on. Put in as much practice as you can, too.

Below – For this tricky little line drawing I used three felt-tipped pens from a child's colouring set to establish shape and surface form.

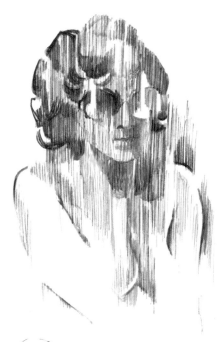

Above – A quick watercolour sketch using a cool, dark background colour to reveal shadow and light on the figure.

Above and below – These two drawings aren't how-to examples, just pieces of creative play on my part. Doodling like this can make a significant contribution to the development of your visual imagination.

Above – Painting from the model in acrylic and coloured pencil.

This watercolour painting was done using a
technique we might call lost-and-found outline.
The edges are emphasized in some places and
'lost' entirely in others. It was the work of several
hours done over two sessions with the model.

Developing and improvising on drawings from the nude model

When you work with a nude model your aim is not ordinarily to produce a finished artwork. Almost always you're producing studies for your personal use only, as a means to some other end. For the purposes of this book, the end to which your life studies should be leading you is of course the creation of imaginative pictures.

As a first step, after the model has left, take a good look at the work you've produced and try to develop your drawings from memory, improvising on your earlier studies. These creative doodles don't constitute a formal exercise that you have to get right – far from it: they're your personal visual thoughts. In the same way that your studies of the model are not necessarily supposed to be finished artworks, neither are these.

I made the drawings on this page after a session drawing the model shown on page 65.

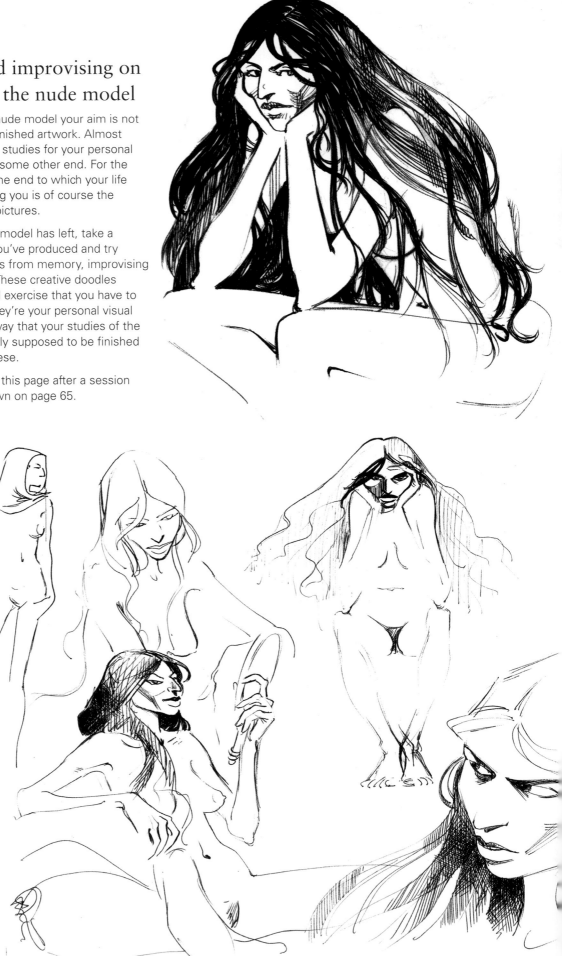

These little doodles of fairies show another lighthearted approach. Whenever you have time to relax with your sketchbook and pencil, remind yourself of drawings you've done when the model's been posing, then draw variations on them. I find the best time for this type of exercise is during the evenings when other members of the family are watching TV or doing their homework. The relaxed atmosphere that reigns at such times encourages my imagination to take flight.

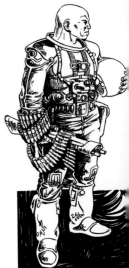

Creating characters from your imagination

If you've been following the advice laid out in the first three chapters of this book, your imagination, because you've been involving it while drawing from observation of the real world, should be ready to step into action when you want to create new images and visual ideas from your mind. That said, when you start your first imaginative project don't expect the ideas to start flowing immediately, as if you'd just turned on a tap. Once you've gained some experience you'll find this will happen more and more, but at the outset your imagination will probably offer just some hints of the possibilities your project opens up.

The advice offered on this spread is derived from *Figure Drawing Without a Model* (David & Charles, 1992), a book of mine devoted entirely to drawing people from memory and imagination.

So, how do you get a grip on that first hint of an idea in order to be able to develop it into a usable illustration?

The illustration at top right of this page shows how you can jot down in very simple terms the posture and proportions of the whole figure before putting in any detail. If you want to make sure the structure and proportions of your final illustration will look right, always create a simple structural diagram like this beforehand. Sit back and check that the shapes look convincing, and don't embark on the next stage of your illustration until you're satisfied. Many beginners, eager to get on with things, miss out this stage, and find that their finished image looks amateurish and just plain wrong. Skip or skimp this step, and you will be able to see the consequences in the amateurish appearance of your pictures.

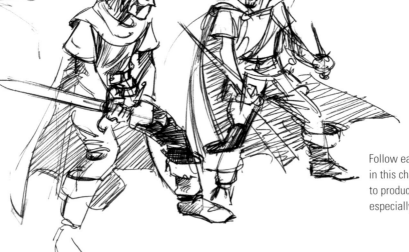

Follow each of the simple steps laid out in this chapter and you should soon start to produce professional-looking drawings, especially if you draw regularly from life.

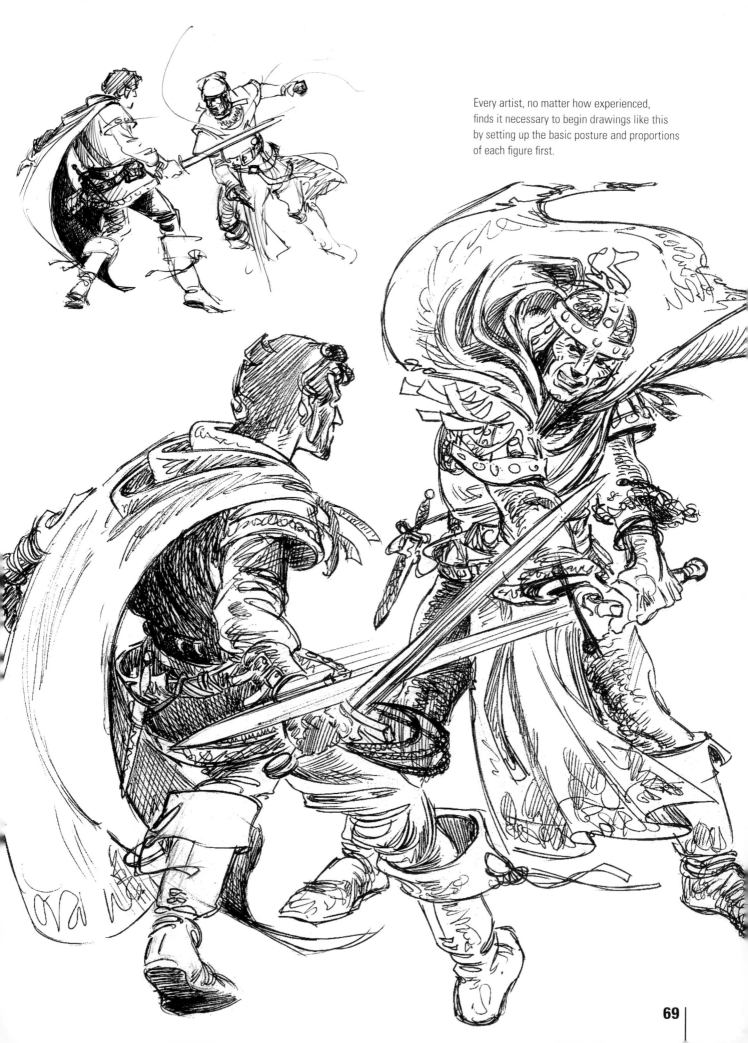

Every artist, no matter how experienced, finds it necessary to begin drawings like this by setting up the basic posture and proportions of each figure first.

Father Time

All the sketching you've done of the people around you, added to all the life studies you've made in the studio, will have given you a tremendous fund of practical knowledge about the structure and proportions of the human body and the ways in which individuals differ from one another. It's this knowledge that your imagination will feed on as you start to create fictional characters.

On this spread I show the steps I went through in creating an illustration for an Eastern European folktale. The brief required an illustration showing a peasant meeting Father Time on a mountaintop. I imagined Father Time seated on a huge throne, pointing down in an accusatory fashion at the peasant.

The important thing to do at the first stage is to *make a start*. You'll find your imagination is a lot better at developing an image from a simple beginning than it is at conjuring up a completed image out of nowhere.

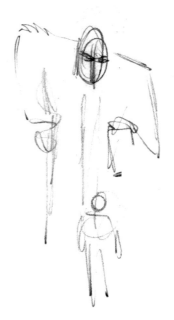

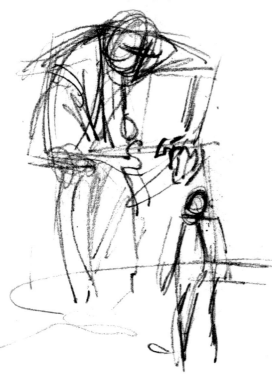

So here (above) is my first visual. It wasn't intended to mean much to anyone else, but for me the drawing was enough to get my creative juices flowing. In case you can't quite work it out, Father Time is pointing downward with his left forefinger at the peasant in the foreground; his right hand rests on the arm of his throne, with his elbow sticking up. The drawing is very small: about 6cm (2½in) tall.

Next I began to develop the image (left). I discarded the downward-pointing finger, but I liked the angle of the elbow sticking up, so I kept that in – although this time it's his left elbow rather than his right, which now rests on his knee. I've moved the viewpoint round a bit, too, to make the silhouette more interesting and to better separate the two figures.

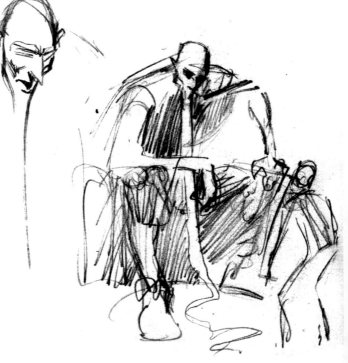

I tried doing a study (right) of Father Time's head to clarify my ideas about his character. The long narrow beard I sketched in on this little drawing gave me the idea that he could have a beard long enough to trail on the ground.

As the next drawing shows (far right), I was now starting to think about what Father Time might be wearing, even though I didn't have any firm ideas on this yet. I posed myself in front of a mirror to see how the arms and elbows would look. I also did some work refining the posture of the peasant to make him appear a bit daunted by the presence of this giant figure.

By now I was starting to draw on a larger scale so I could fill in more of the details; the figure in this drawing (right) was about 16cm (6½in) tall. I was more certain what the face of Father Time should look like, and had a better notion of the clothing he should wear. Also, I began to think it might be a good plan to tie something into his hair – a clock, perhaps – and to give him an hourglass to hold.

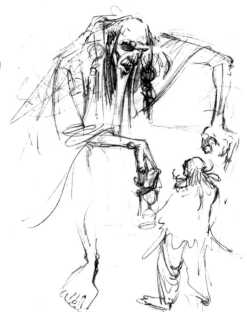

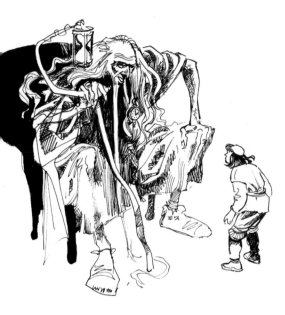

I used a ballpoint pen to draw the final rough (left) that I sent to the publisher for approval. I now had fairly clear ideas about the face and clothing. Rather than simply having Father Time hold an hourglass, I gave him a strange-looking staff to grasp and hung the hourglass on that. Oh, and I did indeed decide to tie a clock into his hair.

For the finished illustration (left), drawn in pen and ink, I worked up the patterns and textures, played with the shapes of Father Time's long, flowing white hair, and created shadow areas with interesting hatched textures.

Mighty Max

The illustrations on this spread are from a different type of project. I was commissioned to create character designs for a children's toy, Mighty Max, described in the brief as a 'streetwise kid of the future, who inhabits a post-holocaust city'. This commission didn't involve any finished illustrations – just lots of visual ideas of how Max might look.

When working on this type of visual I usually establish the posture first with a quick pencil diagram (below, second from left), then fill out the details of limbs and clothing.

I was surprised later to find out that the version the manufacturer had chosen was very like the little chap in the bottom left-hand corner of this page – and that the toy was only about 1cm (½in) tall!

I retained copyright in all the unused designs and determined that one day I'd write and illustrate some children's books featuring one of them. Pressure of work has so far prevented me. When I retire, perhaps.

If I retire . . .

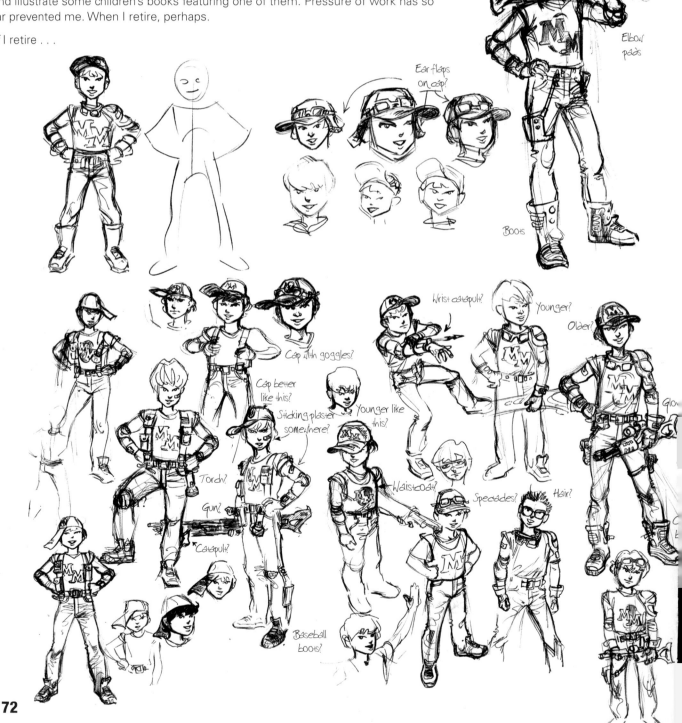

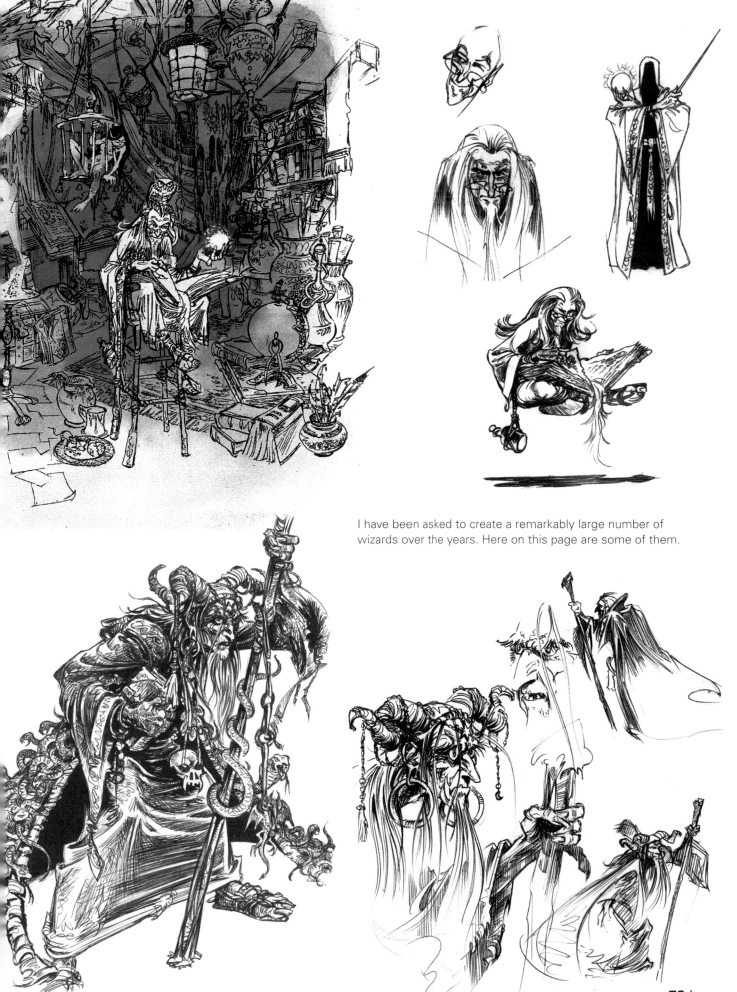

I have been asked to create a remarkably large number of wizards over the years. Here on this page are some of them.

Creating fantasy characters

The drawings here represent another commission I received from
a toy company. My brief was to produce character designs for a series
of 12 fantasy figures, each based on a paragraph of descriptive text.
To be honest, the paragraphs weren't as 'descriptive' as they could have
been! The character depicted here was described as 'an eighth-century
knight… the illegitimate son of a god and a mortal woman… a product
of sorcery… his past is a mystery…'. This didn't provide much useful
visual information to help nail down his actual appearance. However,
if you're familiar with the characters in computer games and comic
books you can guess the kind of figure that's required.

Unlike the case with the previous
commission, the client required a single
finished drawing for each of the 12
characters rather than lots of sketched
suggestions.

For this type of exercise, start by
establishing the figure's posture and
proportions, as discussed on page 68.
If you do the early stages in pencil,
you can erase your working lines as
you embellish him with cloak, armour,
weapons and so on. Facial features
and other details can be first sketched
separately and then added into the
drawing when you're happy with them.

Although you're creating an inhabitant of a fantasy world, remember his practical needs – things like a sharp knife, a length of strong twine or gut, a water container, and so on. I gave this particular knight a huge, voluminous cloak, a garment which can hardly be described as functional, but it looks good – another requirement for this type of work!

It's essential that you begin the final drawing by setting down the basic physical structure and proportions in pencil. This structural drawing can then be given any amount of embellishment without losing credibility.

For fantasy figures like these it's best to begin by drawing weapons, armour and other bits of paraphernalia on a separate piece of paper to establish the figure's general appearance and character.

Space warrior

This was the first character design I did in the series of 12 described on the previous spread. By arrangement with the client, I did it as a trial piece before beginning the rest of the set.

I began with some exploratory idea sketches, inventing plenty of bits of impressive futuristic weaponry as I went. I did the final character sheet, shown on the opposite page, using a pencil and eraser, adding more and more items of equipment. At the end I inked everything over using a ballpoint pen.

Although this was done as a trial piece, it wasn't a free sample. If clients want trial pieces before issuing the full commission, I make it clear these must be paid for; after all, the client has seen other work I've done in a similar vein, so knows I can deliver the goods. Like everyone else in the world, artists can't live on fresh air alone.

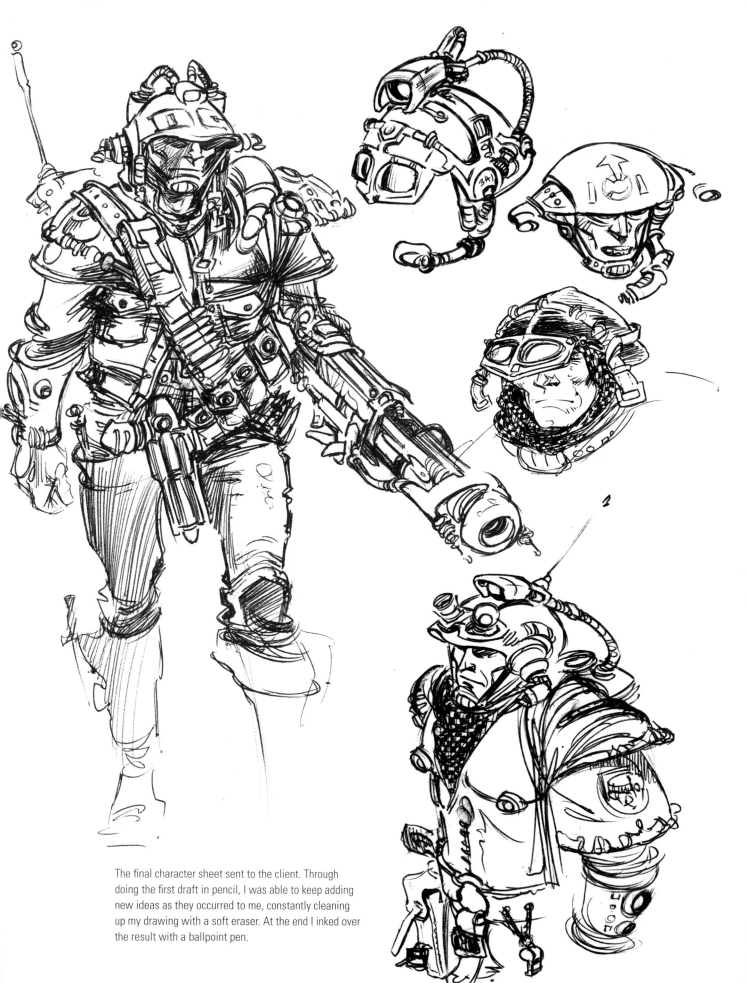

The final character sheet sent to the client. Through doing the first draft in pencil, I was able to keep adding new ideas as they occurred to me, constantly cleaning up my drawing with a soft eraser. At the end I inked over the result with a ballpoint pen.

Soothsayer

Every now and then an image starts taking shape in my mind and keeps nagging at me until I make the time to work it into a more or less concrete form as a drawing, painting or other type of object. I'm sure other artists have the same experience often enough.

This image of a soothsayer is an example. It didn't start as a clear image that just popped into my mind fully formed – that rarely happens to me. Rather, it developed as the ghost of an idea from something else I was working on at the time.

Right – My first visualizations of the soothsayer were ungainly, and the idea seemed to have little or no potential. However, I liked the concept of his having a bird on his head.

Above – In my quest for another approach, I tried posing a model. I began to wonder if viewing the figure from a lower angle might be the answer.

Right – At last the image was gaining the kind of 'magical' look I'd had in mind. Once I'd added the monkish habit, with a hood covering most of the figure's head, I began to feel I was really getting there.

Generally, as shown on the preceding pages, I begin character development by putting down on the page a few lines or shapes as a basis upon which my imagination can start to improvise, but in this instance that approach didn't work. I therefore tried to get a clearer idea of where I could be going with the image by drawing from a posed model. As you can see in the sketches here, I was able to move the idea forward step by step, a little at a time, refining the posture and the shapes of the garment until I reached a result I felt happy with.

As you will have gathered, capturing these 'ghost' images isn't easy, but the process of teasing them out can be fascinating. Unfortunately there's rarely enough time in the busy life of a freelance illustrator to indulge in such activities.

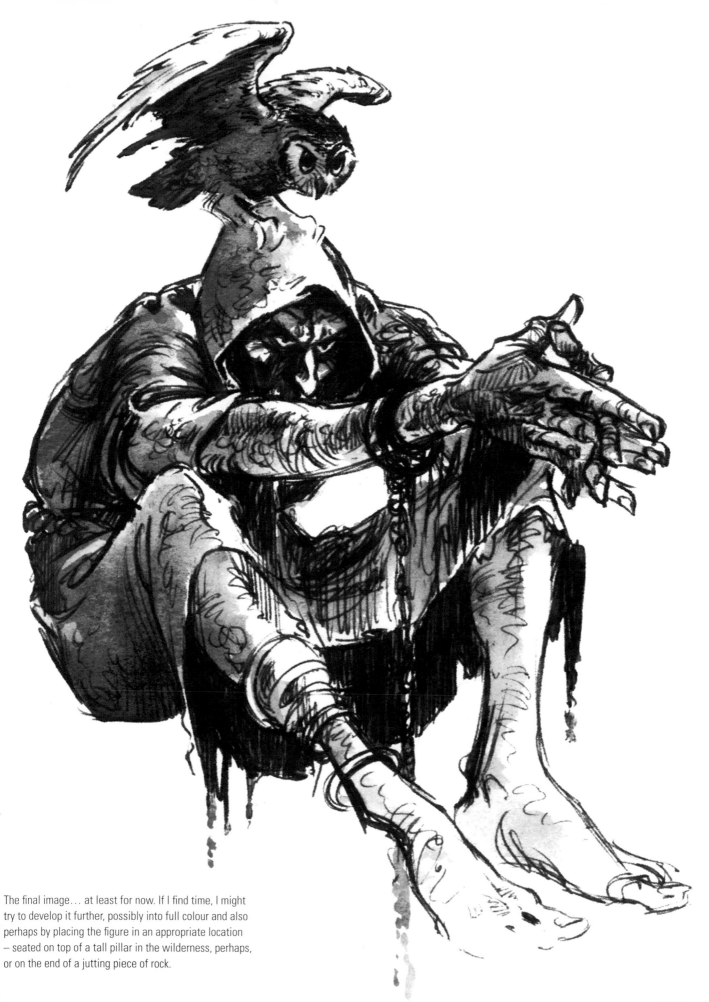

The final image… at least for now. If I find time, I might try to develop it further, possibly into full colour and also perhaps by placing the figure in an appropriate location – seated on top of a tall pillar in the wilderness, perhaps, or on the end of a jutting piece of rock.

Jason and Chiron

Some years ago Usborne Publishing planned an illustrated children's book about the mythical Greek hero Jason and his quest for the Golden Fleece. The first thing publishers of illustrated books often do, before committing themselves to the full expense of producing a new book, is to commission a synopsis and some sample text as well as a cover illustration and a few internal illustrations. Using these, they create either a dummy or a blad* to show to foreign publishers with the aim of persuading them to buy foreign-language editions of the book. In this way, by preselling thousands of copies, the original publisher is able to minimize the financial gamble.

In the early years of his life, Jason was sent to be educated by the centaur Chiron. For the dummy, Usborne wanted a colour illustration showing him with his mentor.

Centaurs were mythical creatures designed by storytellers, not artists. Presumably what happened was that soldiers returned from foreign wars talking of foes with such consummate skill in horsemanship that, on the battlefield, rider and horse seemed almost to be a single creature. As these tales were told and retold, the foreign warriors came to be described as if they were in fact a man-horse. If such creatures existed, then obviously artists were expected to draw them.

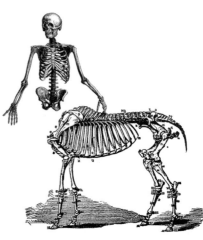

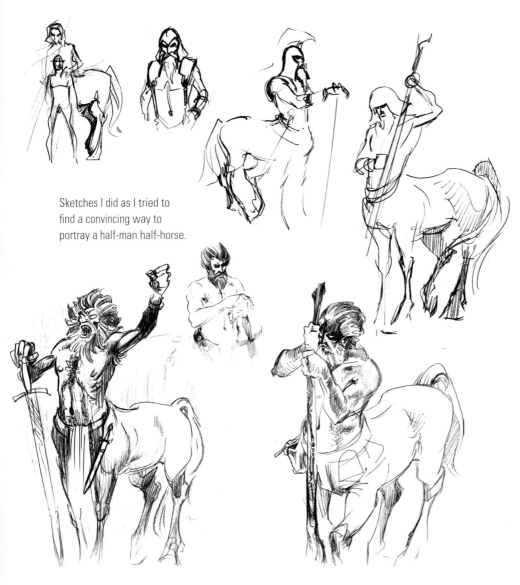

Sketches I did as I tried to find a convincing way to portray a half-man half-horse.

Poor artists! It's very, very difficult to make a drawing of a centaur look convincing. The problem is that the human part of the combo grows out of the equine body where the horse's neck should be. To make sense out of this anatomical nightmare, the artist must somehow find a convincing way to combine a horse's ribcage with a human pelvis – not an easy task, as the attempts on this page demonstrate. I eventually decided to cover up the awkward bit with a loincloth.

Roughly speaking, a dummy is a book of the right size and shape, bearing a printed cover but with all the pages blank. Page mockups, made using sample text and pictures, can be stuck or bound into the front of this book or can be shown as separate items. For a blad (book layout and design) the cover and the page mockups are used to make a printed booklet, copies of which can be given to interested consumers – unlike the case with a dummy, of which usually at most two or three copies are produced.

Now I needed to compose a picture of Jason and Chiron that would hint at their teacher–pupil relationship. My first idea was to show them either side of a campfire at the mouth of the cave in which they lived, but in due course I opted instead for a tableau-style arrangement, with the two standing together as if for a photograph.

The style of clothing young men were likely to wear in Ancient Greece has little visual interest. Unfortunately, it's also well known, so I didn't have much freedom to make it more exciting. I therefore needed to create some patterns and shapes with the centaur to keep the composition lively and arresting. The sketches on this page show my attempts to do this.

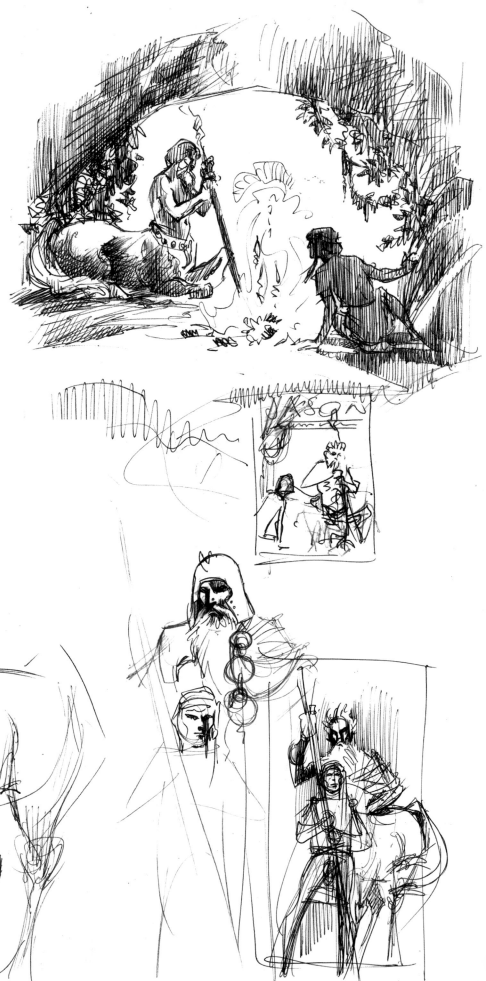

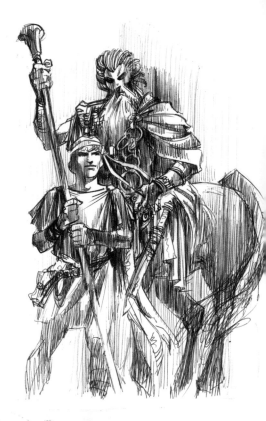

Once I've solved all the problems of character design and composition, I move on to preparing the finished artwork. The first step is to make a detailed drawing in which I can ensure the structures and proportions of the figures are right and organize the areas of light and shadow.

The next stage is the colour rough, for which I usually photocopy the detailed drawing onto thick cartridge paper or watercolour paper and paint on that with watercolour or gouache. I prefer these paints to acrylics. Acrylics are easy to use and pleasingly bright, but are waterproof when dry – and they dry quite quickly. Watercolour and gouache allow you to wash away and rework areas until you're happy with them.

In this instance, I first chose to paint everything in shades of blue. Looking at the result, I decided this was a bit dull, so I tried again, this time imagining there was a warm yellow light source somewhere high on the right, with consequent cool blue shadows on the left.

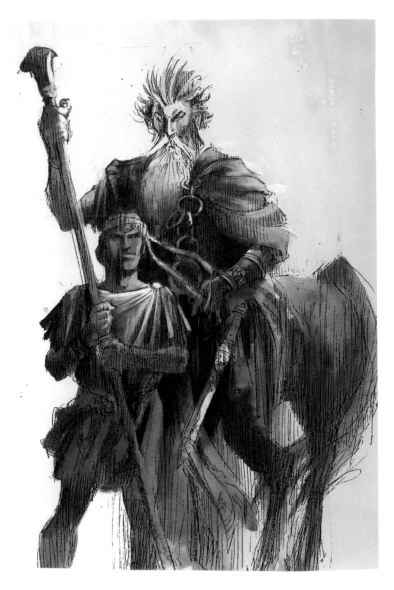

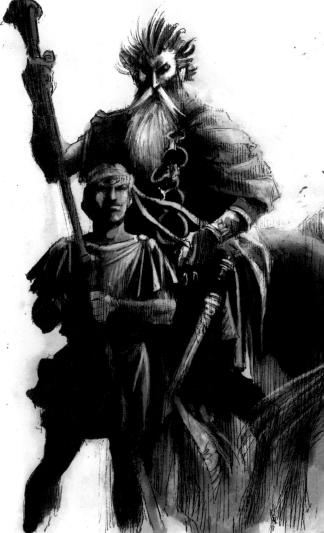

Shown here is the final artwork. I did it in gouache to a size of about A3 (43 x 29cm/ 17 x 11½in). If I were to do it again today, several years later, I'd change the expression on Jason's face, which I'm discontented with now.

Literary characters

Of course, not all of the fictional people you're asked to draw come from fantasy or mythology. As a working illustrator you'll find that often you need to produce drawings and paintings of well-known characters from literature. Many of these already have an established appearance which you won't be able to change too much. Characters like Long John Silver from *Treasure Island*, or Sherlock Holmes and Dr Watson, or Fagin from *Oliver Twist* – these and many others are instantly recognizable to the reading public through the images of them created by the master illustrators of the past.

While you have to make sure your visualizations of such characters are immediately recognizable to the reader, at the same time you want your own versions to be in some way distinctive – to be 'yours'. This sounds like a difficult trick to pull off, but in fact it's often something that takes care of itself without your having to try: all your work will naturally tend to bear your unique personal touch.

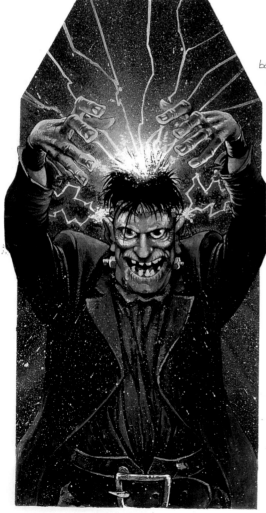

Depicting classic horror-story characters for children's books can be a special case, in that it's likely you will be asked not to make them too frightening. Hollywood moviemakers all too often seem not to understand the difference between horror and disgust, but the publishers of children's books must generally be a lot more careful: the children themselves may want the illustrations to be as frightening as you can make them, but most often it's not the children who are buying the book but their parents! That's why the Frankenstein monster shown here looks like a nice guy who was *pretending* to be scary, just for fun.

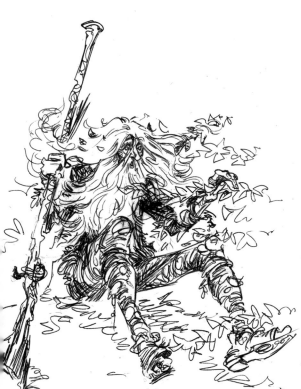

Left – An unpublished illustration showing Herman Melville's characters Ishmael and Queequeg from *Moby Dick* (1851).

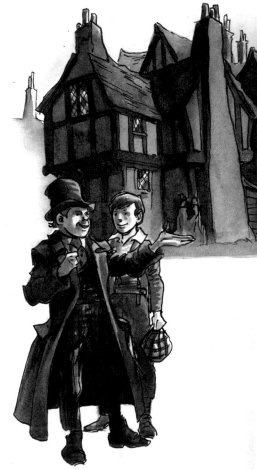

Right – Charles Dickens's characters Oliver Twist and the Artful Dodger, painted for an educational book.

Below – Long John Silver from Stevenson's *Treasure Island* (1883). Only when gathering the illustrations for this spread did I realize I'd used the same reference photo for the seagull here as I had a decade earlier for the *Moby Dick* picture above!

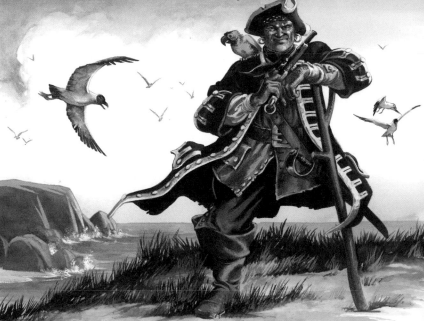

Above – Preliminary sketch for the cover of a children's edition of Washington Irving's story 'Rip Van Winkle' (1819).

In search of Robin Hood

When a version of a classic tale relies heavily on its illustrations, the publisher will regard the portrayal of the main characters as an important factor in the book's potential success. The illustrator is often required to submit several different portraits of these characters for approval before starting work on the set of illustrations for the book.

A few years ago I was commissioned to illustrate a book of Robin Hood stories. Since Robin is such a well-known figure, images of him have to be immediately recognizable. At the same time, you can't just rehash older visualizations. On this page are some of the many drawings I did while searching for the 'real Robin'.

Hat looks ok but it's too flamboyant

The Hat!

Some of the 50 or so working drawings I produced as I sought to establish my own image of Robin Hood. The publisher and I eventually concluded he looked better in a practical outfit than a flamboyant one. We also decided to ditch the hat.

Opposite – My final visualization of Robin, as seen on the cover of Tony Allan's *Tales of Robin Hood* (Usborne, 1995). My original plan was that the title be overprinted across the top of the picture so that the sun shone through the 'o' of 'Robin'. For various complicated reasons the background of sun and leaves was replaced by a nebulous haze.

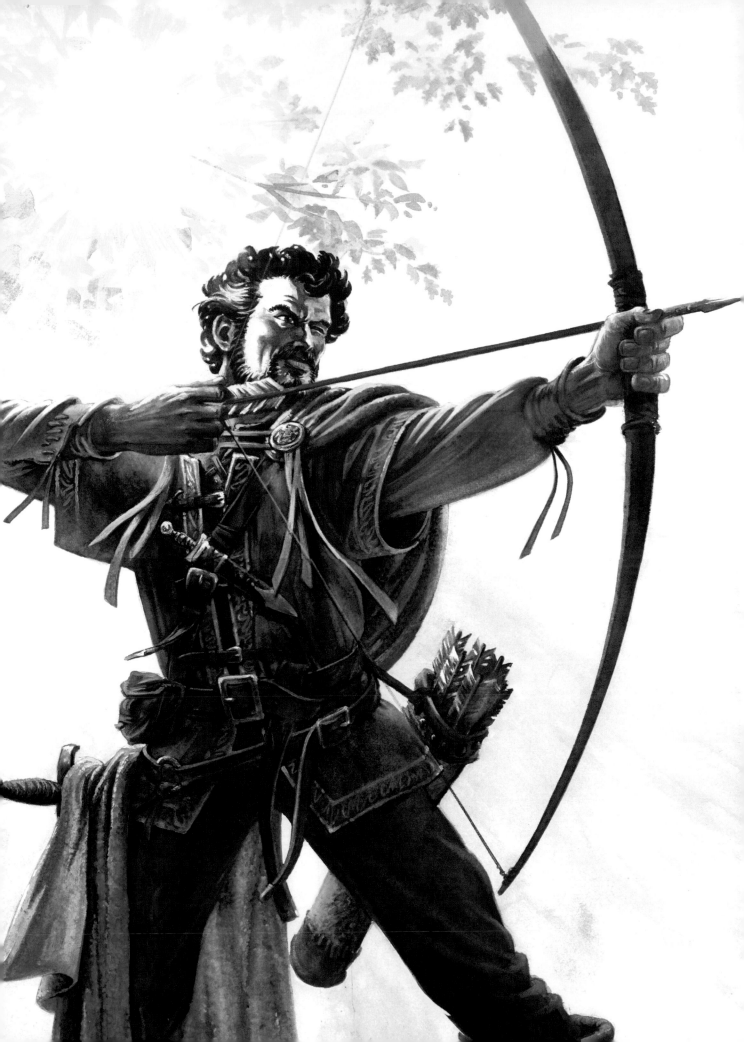

In search of General Primrose

When creating characters for graphic novels or comic books you need to have a very clear picture in your mind of how the major protagonists look, because you will have to portray them from all angles in a wide range of moods, lighting regimes and locations. Before you so much as think of the first frame of your graphic narrative, you must explore the dramatic potential of your visualizations and produce a character sheet for each one, displaying him or her in a diversity of poses. The publisher will normally insist on seeing and approving this character sheet before you go any further.

The character here, created for the graphic novel *Maiwand*, is based on a real historical figure. I found a portrait of him in a copy of *The Illustrated London News* dating from 1880. I imagined him being an inordinately whiskery man with long, thin arms and legs, prone to making pompous, outrageously racist pronouncements, and smelling strongly of pipe tobacco and malt Scotch. His long campaigns in India and Afghanistan are reflected in his lifestyle as much as in his appearance.

On this page are some of my early explorations of the character General Primrose, as I attempted to establish his physical proportions and experimented with some facial expressions.

The characters in graphic narratives need to be very distinctive in appearance to ensure that readers can differentiate between them at a glance.

Composition techniques

The term 'composition' refers to the way the elements that constitute a picture are arranged in relation to each other. This chapter focuses on the decisions we make about where to put things within the picture area.

Most of the time it might seem that artists make such decisions on the basis of nothing more than 'what looks right' – that it's just a matter of putting the pieces where you fancy and hoping everything will work out okay. But the decisions we make when creating a picture are not so superficial as that.

All art has a *purpose*, whether it's a picture, a poem, a symphony, a pop song or a ballet dance. As artists, we want anyone who looks at our efforts to be enriched in some way by the experience. Understanding composition can ensure our work does its job effectively.

Composition rough for an illustration about the attack on the Tsar's Winter Palace in St Petersburg during the Russian Revolution of 1917.

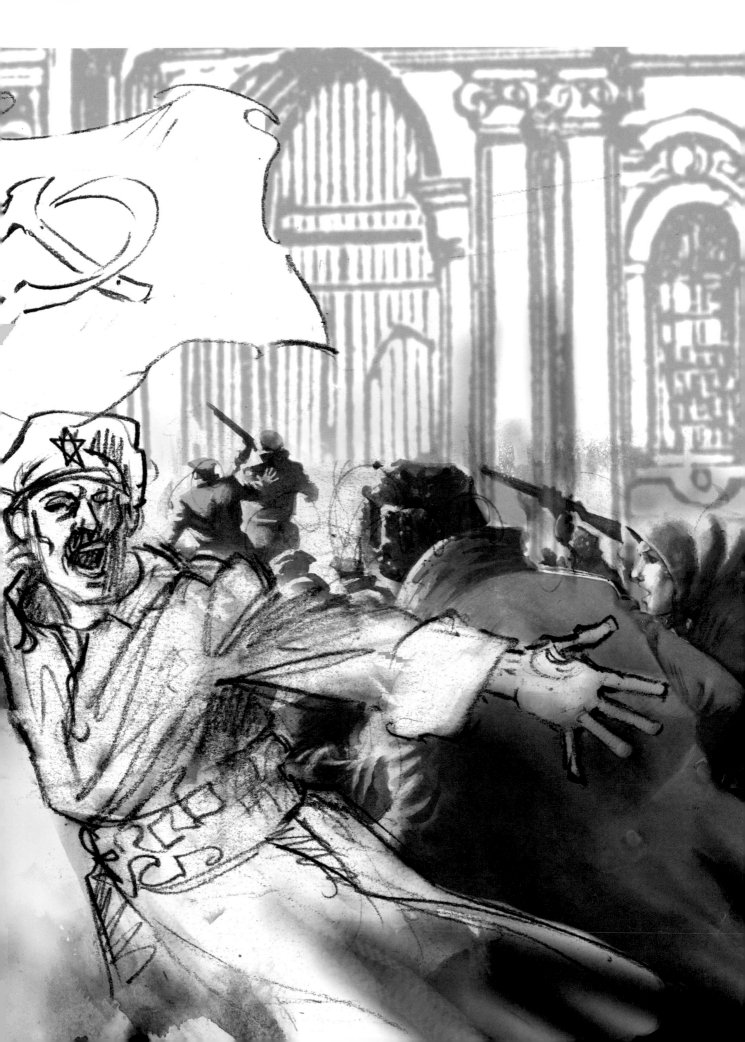

On saying what you mean

We've all had the experience of looking at a picture that seems uninspired and uninteresting. Often we can recall another treatment of the same subject that for some reason was arresting and somehow more satisfying.

In Chapter Two I made the point that when we draw a picture, we don't want everyone who looks at it to be left wondering what it's about. We want our pictures to speak for themselves. The decisions we make about style, viewpoint and general arrangement affect their underlying meaning. A good understanding of composition can ensure that our work says what we want it to say.

Above and below –Two versions of an illustration for the graphic-narrative book *Ten Minutes*.

It's often hard to put into words the exact reasons why we like or respond to a particular picture. This is why we use the term 'visual language'. By this, we simply mean that a picture can speak to us in a way we understand intuitively, 'just by looking at it'. It's only when we want to tell other people about it and we try to translate the picture's meaning into words that the difficulties start.

Shown left are two versions of a drawing from a graphic narrative; the message is supposed to be humorous but also slightly scary. I showed the first version (the upper drawing) to some artist friends, and they all said it was a bit too 'soft' for the subject. My second attempt says very clearly (I think), 'This is kinda scary… but it's also great fun.'

I achieved the effect by using a more rugged line and spattering ink around. The drawing thus has more vitality and a nice chaotic feel.

Left – Done for a recent OUP edition of John Buchan's *The Thirty-Nine Steps* (1915), this picture evokes the ambience of a rich bachelor flat in Edwardian London through the use of a soft 2B pencil on rough-textured paper.

The message of the drawing shown right concerns hope and optimism. That message is conveyed partly through showing the figure reaching upwards, with the feathers radiating outwards from his hands, and partly by drawing the tips of the wings darker than the rest, so that he appears to be bathed in light from above.

I wanted a fairytale quality for the illustration below, so I adopted a very decorative line style. Shown far right is an enlarged detail in which you can see the line quality more clearly. The illustration at bottom right is, in direct contrast, full of dark shadows and crumbly textures to convey a rather creepy atmosphere.

The kind of outline we use, the patterns, textures, treatment of shadows – these are some of the means we use to help our pictures speak directly to the emotions of the audience.

Above – One of a series of drawings I did many years ago for a private project.

Left –'Jemmy Hurst – An Oddity', an illustration done for Sabine Baring-Gould's *Yorkshire Oddities*. In the enlargement (**right**) I have corrected the man's right hand.

Below – An illustration for *Penguin Chillers*, in which a feeling of intense drama is achieved through the use of dark shadows and broken textures (Penguin 1998).

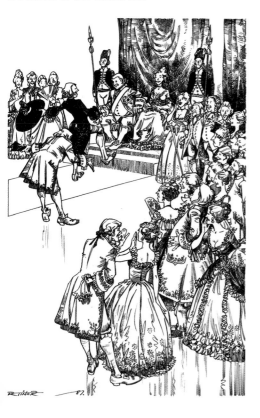

Viewpoint

The position from which the subject of a picture is viewed can profoundly affect its visual message. A low viewpoint, so that we're looking upward at the subject, can suggest dominance, power, strength or pride. A high-angle view, looking down, can emphasize qualities such as pathos and vulnerability in the subject.

From left to right, above – Three pictures that show how looking up at a subject can accentuate power, pride and strength: a story frame from 'The Rat Pack' (1979) in the comic *Battle Action*; an illustration for the novel *The Far-Enough Window* by John Grant; and 'Castle', a demonstration painting done in acrylics.

Looking down at a subject can emphasize qualities such as vulnerability, as in this story frame from 'Cannon' (1988) in the sports newspaper *Match Weekly* (**left**) and Charles Dickens's Oliver Twist, famously asking for more gruel in the workhouse (**right**).

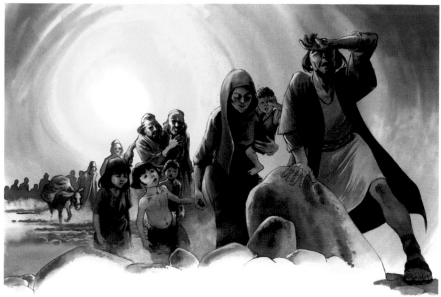

Above – A low viewpoint enhances the sense of the threat these Afghan soldiers pose in a narrative frame from the graphic novel *Maiwand*.

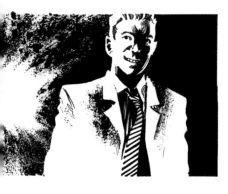

An illustration done for *Penguin Chillers* (**above**); a story illustration for the educational partwork *My Bible* (1999) (**above right**).

A low viewpoint is useful in other ways too. In the picture shown left, the low angle gives focus to the nasty expression on the boy's face, while in the picture above it helps convey how these nomads are suffering in the desert heat. In short, looking up at a subject can be an effective means of emphasizing circumstances and emotions.

Our choice of viewpoint is an important factor in giving our pictures eloquence. All the pictures on this spread have a narrative dimension: each is telling a fragment of a story. There are other decisions we can make to embellish this story element in our pictures. Among these is the matter of distance – whether we see our subject in close-up or in a long shot. A close-up emphasizes character, a long shot the importance of location.

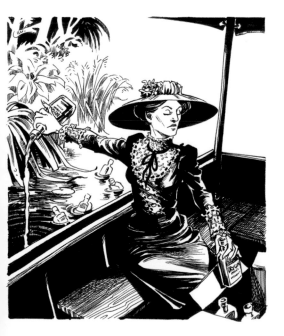

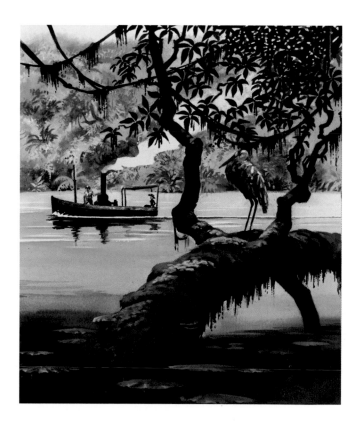

An interior illustration and the cover painting for OUP's 2005 simplified text edition of C.S. Forester's *The African Queen* (1935). The close-up viewpoint (**above**) focuses the audience on the subject's character; the more panoramic viewpoint (**right**) conveys the setting.

The centre of interest

In every picture there is one area that's especially important – one small area where you have placed the person or object that you want your audience to take particular notice of. We call this area the *centre of interest*, or *focal point*.

In the two versions of a graphic-narrative illustration below, depicting a World War II sabotage incident, the centre of interest should obviously be the fleeing commandoes. Indeed, you might think that you would focus on the skiers wherever in the picture they were – but you'd be wrong! The composition of the picture dictates that your eye is drawn to the area of snow-covered hillside on the right, whether the skiers are there or not.

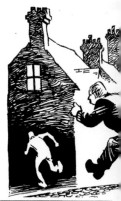

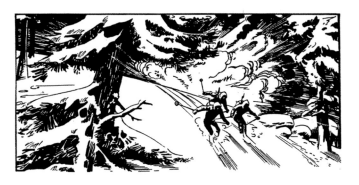

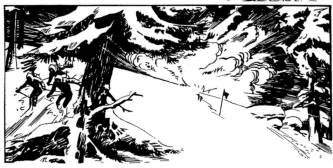

Above – A story illustration from the comic *Battle Action*, 1980.

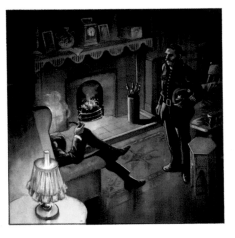

Right – It's a general rule that you shouldn't obscure the most important feature of your centre of interest. However, the brief for this illustration for Helen Brooke's *Mystery in London* (OUP, 1999) specifically required that the lead character's face be hidden.

Below – A story frame from 'Cannon' (1988) in the sports newspaper *Match Weekly*.

As creators of pictures we have to be in control of the way in which our work is viewed and understood by the audience. We must direct our audience's attention, and never allow any confusion to arise in the viewer's mind as to what a picture is about or what it has to say. We're in charge of what the viewer sees first, what the viewer regards as important, the route the viewer's eye takes in scanning the picture, and the way in which the viewer perceives what we have to say.

It's commonly said that the centre of interest needs to be big and near the middle of the picture – indeed, I've seen instructional books that state this as an invariable rule. Well, it's not true. There is no such rule. In each of the illustrations on this spread the centre of interest is quite small and located well away from the middle – near an edge or even in a corner. In each instance it's not the material near the middle of the picture that is most important.

Above – An illustration for H.G. Wells's *The War of the Worlds* (1898), commissioned for an educational book.

Above left – The focus in this illustration from John Francis's *Dales Law* (Smith Settle, 1991) is the fleeing figure at the far left.

Right – In this illustration for *Mystery in London* the focal point should have been the lighted front door of the cottage. I made the mistake of painting the sky too light, and by so doing drawing the viewer's attention to the train at the top.

Below – In this story frame from 'Cannon' the focal point is the lighted window at far right.

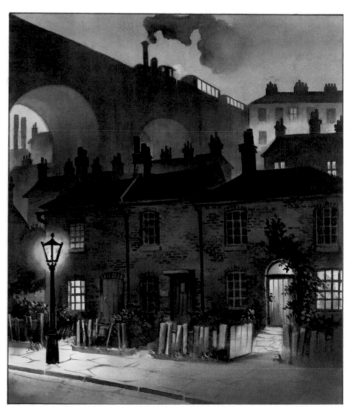

Related shapes

In the illustrations at the top of this spread, the cars are not all exactly the same but they're similar enough to each other that no single car attracts your attention. Even though each has something about it that's unique, no single vehicle stands out from the rest. They form what is termed a *related-shape pattern*. When there are only cars in the picture, it has no focus. But introduce a human figure amongst the cars and immediately it becomes the focal point. It doesn't matter where you place the man: you intuitively regard him as the subject of the picture. That is because this shape is significantly different from those of the cars – the odd one out.

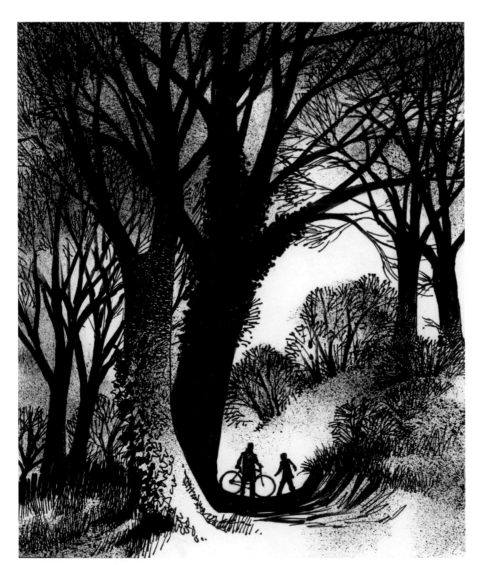

This is not because people are intrinsically more interesting than cars, as is demonstrated by the picture below, which has several human figures but only one car. This time we immediately assume it's the car that's the subject of the picture.

In the larger illustration on this page, almost the whole area is occupied by tree shapes… and so you assume the subject must be the two people with the bicycle.

Manipulation of related-shape patterns can be an important compositional technique in controlling the way people look at your pictures.

Left – Illustration for the children's book *Sherlock Holmes and the Duke's Son* (OUP, 2002).

Left – If there are many human figures and many cars, once again we tend to see the picture like wallpaper, with no single image dominating.

Right – Introducing a new shape (here a tree) marks one small area as important.

Left – If there are related-shape patterns of trees, haystacks, cornfields, poppies and flying birds, then it will be the fox that we focus on.

Below – I placed a car among a multitude of people to attract your eye to that spot. The two men conversing next to it become part of the focal point as well.

Left – The centre of interest in this picture of a busy Victorian street, done as an illustration for Helen Brooke's *Mystery in London*, is the tyre track on the road.

Below – The cars form a related-shape pattern that emphasizes the importance of the two figures. Both this and the picture above are narrative frames from 'Cannon', 1988.

Other ways of attracting the viewer's eye

A further useful technique for attracting the viewer's attention to the centre of interest is to place it in an area that's either significantly lighter or significantly darker than the rest of the picture. In the illustration to the right, done for a Sherlock Holmes story and showing a bird's-eye view of Baker Street, my intended centre of interest is the tiny figure shown hailing a hansom cab near the lighted shop windows. Although I lavished a lot of care on the horse-drawn vehicles and the bustling groups of people lower down the picture, it should be intuitively obvious that they're not the main subject.

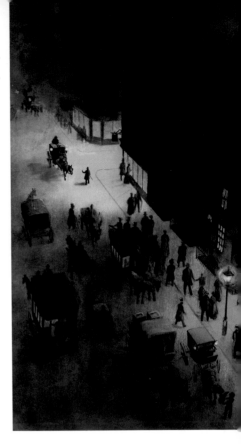

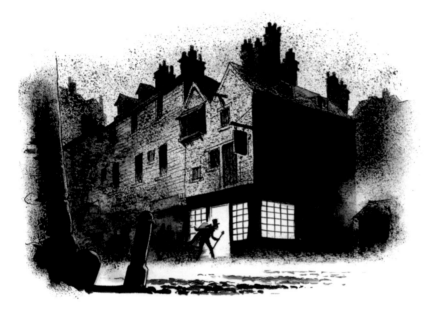

Yet another approach is to frame the focal point within a window or doorway, as in the illustration above, or to find some other framing device, as in the narrative frame below left. I draw attention to the two walking figures in the illustration below right by making them break out of the bottom of the picture.

In the painting on the opposite page, the sunlit area contrasts with the shadows elsewhere, drawing the audience's attention to the figures.

Left – Illustration from OUP's 1995 children's retelling of Robert Louis Stevenson's *Dr Jekyll and Mr Hyde* (1886).

Opposite – Illustration from Tony Allan's book *Tales of Robin Hood*.

Bottom left – Frame from the story 'Future Shock' (1984) in the comic *2000 A.D.*

Below – Frame from the story 'Cannon' (1988) in *Match Weekly*.

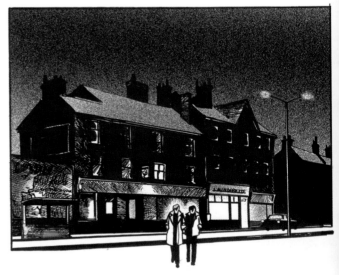

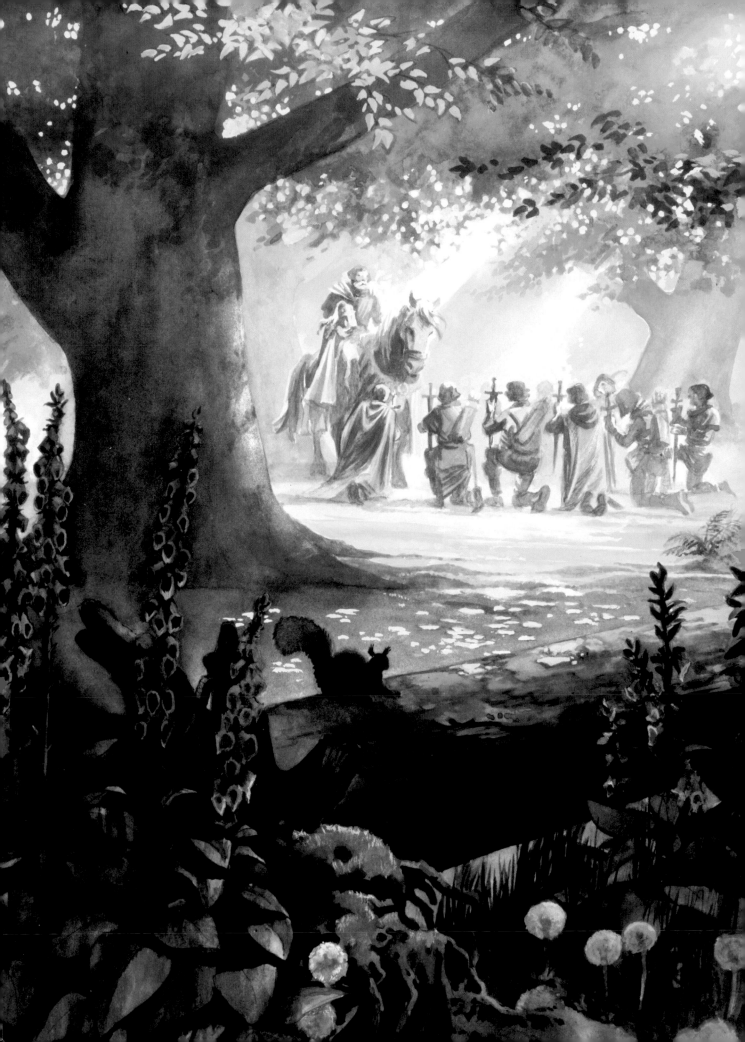

Guiding the viewer's eye

As artists we want to control the route the viewer's gaze takes over the picture area, and this can involve more than just guiding the eye to the centre of interest. Yes, the focal point is the most important part of the picture, but there may be other parts that are essential to the picture's message. This can be particularly true if the picture is a story illustration.

At top right of this page is a small drawing of a row of five trees. Although each has its own configuration and arrangement of branches, they form a related-shape pattern and consequently no individual tree attracts our attention at the expense of the other four.

In the picture below it I've drawn a pathway in order to make you perceive one tree as more important than the others. It's an odd fact that, when we look at pictures, we seek out pathways along which our attention may travel towards an understanding of the message the picture has to convey to us. Most often what we're looking for is some evidence or indication of an event – something to satisfy that unexplainable urge we all have to be told stories.

There are other methods whereby we artists can offer such pathways – pointers to the centre of interest – and I've illustrated a few of them on this page.

Any type of feature can be placed in our picture in such a way that it performs the function of a path. The branch or twig in Illustration C works just as effectively as a literal pathway in individualizing one of the five trees. A somewhat more obvious approach, shown in Illustration D, is to have a person pointing to the tree you want the audience to focus on.

You can group objects and/or figures so that they collectively lead the viewer's eye along the route you want it to follow, as with the line of people in Illustration E. This same approach is used in the bird's-eye view of Bombay Harbour at bottom left, where birds and boats form a visual pathway to the quayside.

A

B

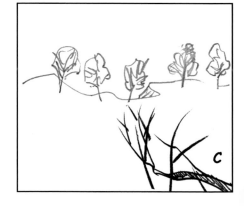

C

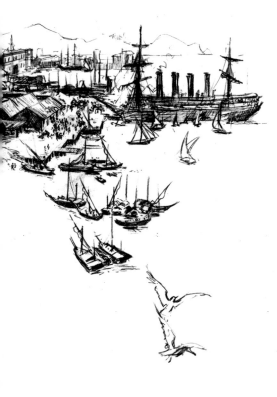

Left – This rough for a narrative frame in the graphic novel *Maiwand* shows how the 'pathway' techniques rather crudely rendered in the diagrams of trees (**A to E**) can with seeming naturalness be incorporated into a more realistic depiction.

D

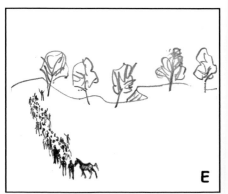

E

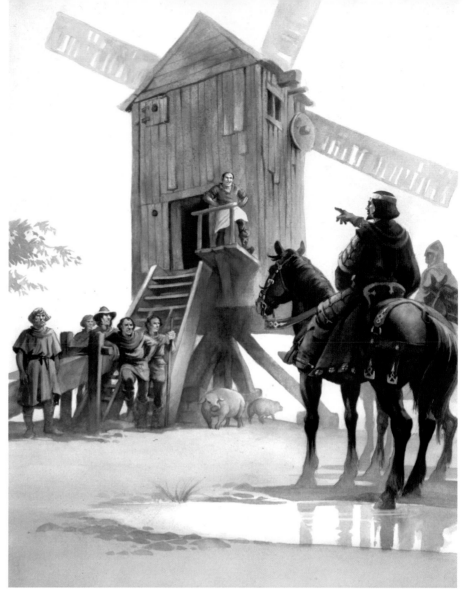

Above – An illustration for John Francis's *Beyond the Brass Plate* (Smith Settle, 1993). The foreground bookshelves act as a pathway along which our eye is guided to the shop window and the incident it frames. The inquiring gazes of the people there lead our attention to the book in the man's hand.

Below – Every line, movement and gaze is directed towards the pig in this illustration for the same author's *Gumboot Practice* (Smith Settle, 1989).

Above – In this scene from Tony Allan's *Tales of Robin Hood*, the eye is led across and around the picture area from the foreground figure of the Sheriff of Nottingham. His pointed finger takes you to the blue-shirted miller, whence the steps lead you down to the group of peasants, whose resentful stares take you back to the Sheriff.

Above – 'The highwayman came riding, up to the old inn-door', according to Alfred Noyes' poem 'The Highwayman' (1906). In this illustration the strip of moonlight ensures you don't for one moment think he's simply riding past.

The narrative dimension

Through judicious choice of viewpoint and line-style, and by controlling the route the reader's eye takes through the picture, we can make sure that what the picture has to say is clearly understood. In the story illustrations shown here you can see how I've used the techniques outlined in this chapter in order to control

- what is seen first
- what is seen as important
- the route the eye takes around the picture area
- the way the picture's message is perceived.

With each picture, the audience should be in no doubt as to what is going on, what kind of story this is, the ambient mood, and who or what is important in the illustration. It's in ways like this that the illustrator can make such an important contribution to the narrative, providing atmosphere and location detail and even – through lighting, facial expression and body language – the feelings and character of each of the individuals involved.

It's a sad reflection on the art education we give our children that the way good illustration can enrich the experience of reading is largely ignored by most publishers of fiction today. Any professional artist will tell you horror stories about important areas of their illustrations being hacked off by picture editors who think the sole function of an illustration is to show the reader what something looks like.

Opposite – An illustration for Tony Allan's *Tales of Robin Hood*. Will Scarlet and Much set off on a journey. But they're not the only important characters in the illustration....

Below – In this illustration for an OUP edition of *The Thirty-Nine Steps*, the hero, Richard Hannay, is distinguished from the other figures because he's not wearing a dark jacket. The focus of the illustration is the book, because that's where everyone's staring.

Top right – Cover illustration for Rita Ray's *Ryan of the Redcaps* (Stanley Thornes, 1998). In this story a boy becomes convinced that his basketball boots bring him skill and luck.

Centre and bottom right – Done for Helen Brooke's *Mystery in London*, these two illustrations of the same murder scene convey widely differing messages. The upper picture diminishes the human tragedy; the lower one stresses its pathos.

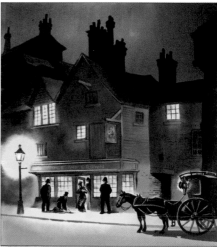

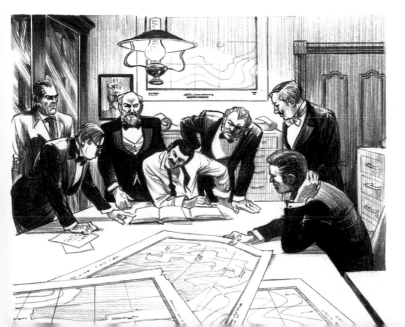

Illustration

Throughout this book I've focused on how to bring your imagination into play when creating pictures. The main concentration has been on techniques you can use to make your drawing more inventive and your finished results more evocative for your audience – rekindling memories and moods – and better at communicating your selected narrative message.

An illustrator is someone who believes that he or she is sufficiently skilful in these techniques to presume to offer his or her imagination for hire.

Illustration is bespoke art – made-to-order pictures – of which the shape, size, subject matter, delivery date and, to some extent, media are dictated by the client.

As an illustrator, you encounter some odd customer requirements! This illustration of Lot and his people in quest of the Promised Land, done for a partwork called *My Bible* (1999), was a very unusual shape. The publishers demanded that it should be a complete triangle. For its appearance here I've lopped off the left-hand side, which in the original illustration tapers off to a very fine point.

Before examining some of the practical aspects of placing your imagination at other people's disposal, we must first establish what an illustration is *for*, then we can be clear about what we are setting out to achieve when producing one. In practice, an illustration can have one or more of the following functions:

- to *decorate* – to make a poster or a page look nicer
- to *inform* – to show what something looks like, or how it works
- to *narrate* – to contribute to the telling of a story.

Another function is to *communicate an emotion or mood*; in our discussions in this chapter we'll treat that as part of the storytelling function.

Above – My first rough for the cover and a development sketch of the group of witches.

Left and below – After the publishers had decided that Macbeth should be omitted, I did various development roughs using the figures of the three witches alone.

Left – The final design rough sent to the publishers for approval. This piece was done in the late 1990s.

Bottom left –The final colour rough exhibits the moody, mythical atmosphere I wanted to capture. I used ballpoint pen for the drawing and gouache for the colour.

Book cover illustration

Some people in publishing and bookselling look upon cover illustrations as mere marketing tools: as soon as the customer has reached into their pocket for the money, the role of the cover is over. In reality, of course, a fine cover illustration (and good cover design) will add greatly to the value of a book in the owner's eyes long after the original purchase has been forgotten.

The worked example shown on this spread was for a young people's retelling of *Macbeth*. Of all Shakespeare's plays, *Macbeth* is the one most concerned with fate and destiny. In an opening scene, Macbeth meets three witches on a lonely heath and is told what his future holds. This was the scene chosen to be the basis of the cover illustration. Clearly it didn't just have to depict the event but had also to reflect the scene's magical/mythical quality.

My first attempt showed Macbeth on horseback in the foreground, shocked as the witches accost him. The publishers, Usborne, decided they wanted just the witches. The resulting 'tableau' style of illustration is typical of a school of American illustration epitomized by the work of Frank Frazetta. It's not a style I generally adopt – not least because Frazetta is a better painter than I am!

Most of the steps in the creative process are shown here, including the colour rough and (opposite) the finished artwork. As with most book covers, this one has a relatively clear area left at the top for the title lettering.

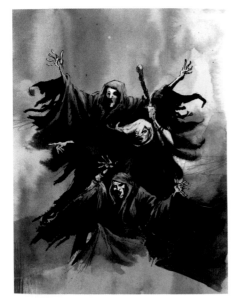

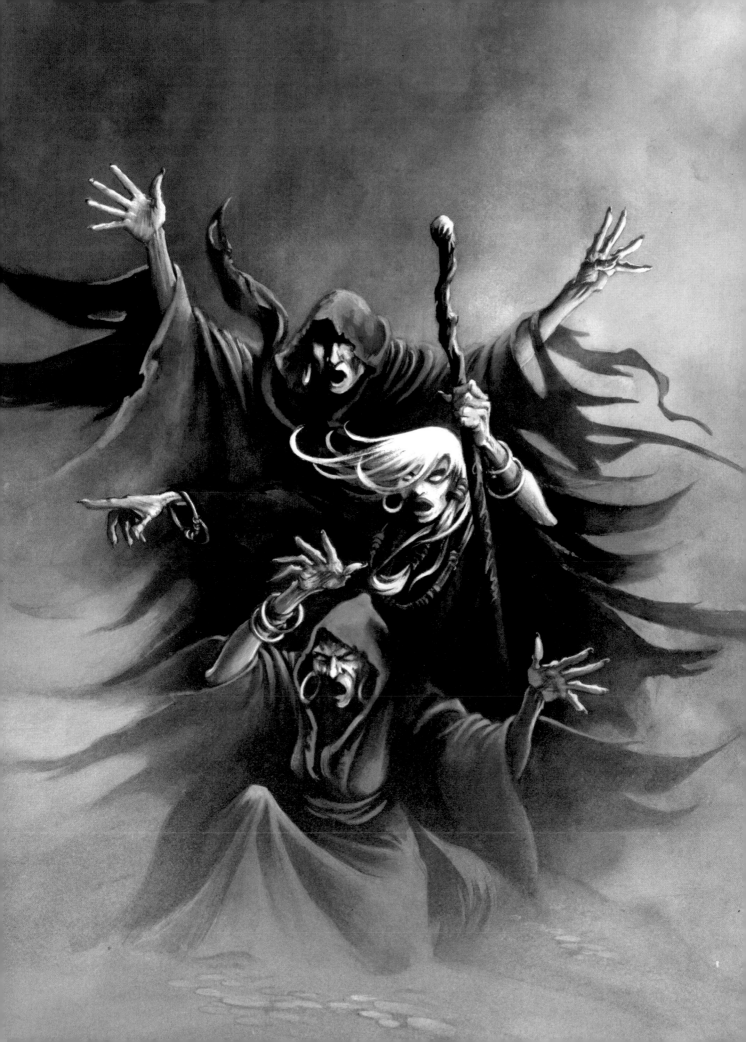

Tales of Knights and Chivalry

At the top right of this page is the brief I received, from Usborne Publishing, for a book cover painting. It looks unusually informal, with a sketch and odd notes jotted on it, because I had at the time built up a good rapport with this publisher, and we knew pretty well what to expect of one another. The brief gave me all the information I needed: the dimensions of the book, the area required for title lettering, and so on. There are a number of additional instructions which were probably appended after discussions among the editorial staff – 'Put the knights on horseback', 'Old Masterish feel – rich feel', that kind of thing. In short, a dream project for an artist!

Please fax pencil rough before going ahead

Two knights fighting on ground

Horse and castle in background

The knights on horseback

Lots of detail, colour, old Masterish feel, rich feel

Actual size **276 x 216** (leave **15mm** bleed all round)

Purchase order to follow

Above – My initial brief, including the editorial team's comments and additional instructions.

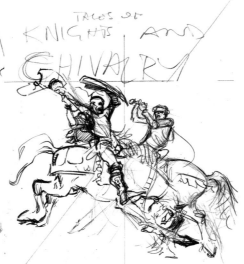

Above – The first idea roughs were as usual very rudimentary, but established the general design.

My first idea sketch was very rudimentary, but I liked the nice lively posture of the foreground horse. This was important: the scene has a tableau arrangement, so its main elements needed to have a lot of vitality, so that the final picture wouldn't look static and dull. All my subsequent development drawings, done as usual in ballpoint pen, aimed to amplify and embellish the dynamic impact.

In the final painting I increased the liveliness by emphasizing the sweeping curves of the fabrics and the aggressive body language of the knights. I also enhanced the sense of a clash of arms by implying a radiant light source in the little area between the two knights, right at the centre of the design.

The final artwork was done in gouache on Not surface illustration board, and was 42cm (16½in) high. As always, I painted the light first (with a radiating pattern), then the castle, and finally the foreground. Painting the foreground took about four days.

Above – The final rough for the cover that I sent to the publishers.

Right – The colour rough established the atmosphere and rich colour scheme requested in the brief.

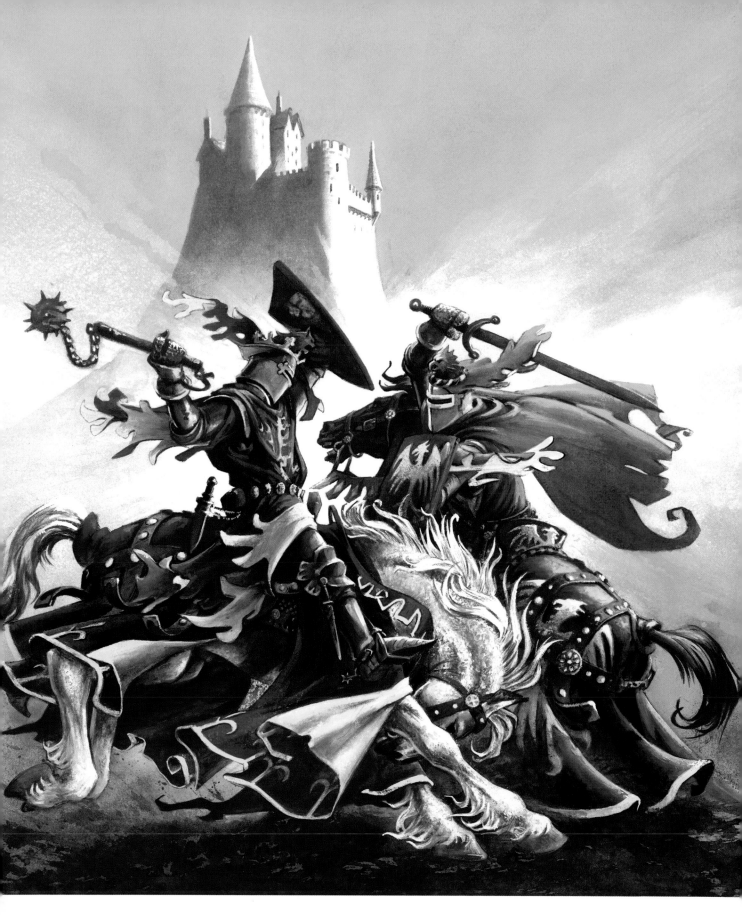

Painting commissioned by Usborne Publishing for the cover
of *Tales of Knights and Chivalry*. The area at the top was left
uncluttered to allow for the title lettering.

Jason and the Golden Fleece

As mentioned on pages 80–83, I was commissioned by Usborne Publishing to provide cover and interior illustrations for a children's book about the mythological hero Jason. It told the story of Jason's life from his upbringing by Chiron the centaur to the great climax of his career, the capture of the Golden Fleece. The publisher wanted the cover illustration to show his encounter with the dragon guarding the Fleece.

According to the text, when Jason found the Fleece it was hanging over a branch of a tree. The dragon was coiled around the tree's base. Jason had enlisted the help of Medea, a devious sorceress. The plan was that while Jason distracted the dragon's attention, Medea would flick a few drops of sap from a magic juniper plant into the creature's eyes to make it fall asleep. As the monster slumbered, Jason could steal the Fleece.

I started by visualizing the dragon, drawing several versions of it in ballpoint pen as I sought the right approach. I decided to avoid the traditional fire-breathing Northern European image of a dragon because so many illustrations of them have been published in recent years that I felt it had become something of a cliché. Instead I opted to make my dragon more like a giant lizard.

As usual, I had to leave an area near the top uncluttered for the title and author's name.

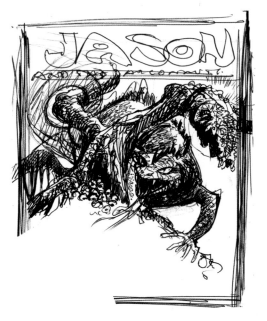

Initially my dragon (**above**) was a hefty beast. He looked not so much impressive, more as if he had a weight problem, so I chose to make him a bit more sinewy and vicious-looking for my colour rough (**right**). Unfortunately, the publisher didn't think this was spectacular enough.

Below – The figures of Jason and Medea were less of a problem, although I changed them, too, as the illustration progressed.

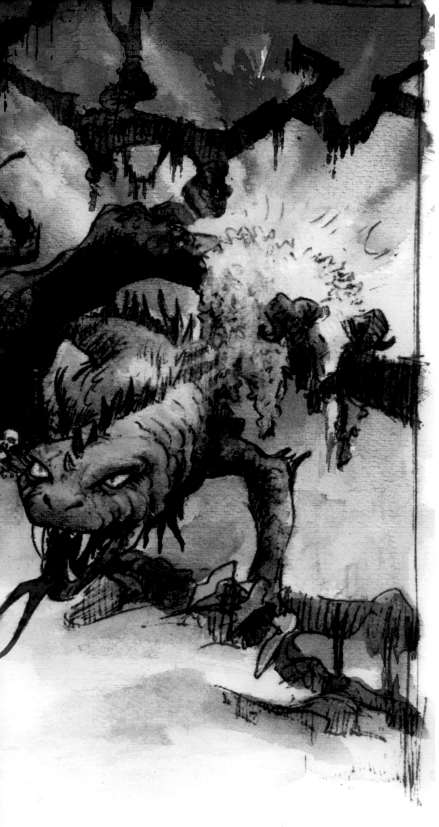

Above – I did plenty of doodles of the dragon before embarking on even the roughest of my cover roughs. Here's what I think is my very first, reproduced to the same size as my original.

Below – The cover illustration begins to take its final shape.

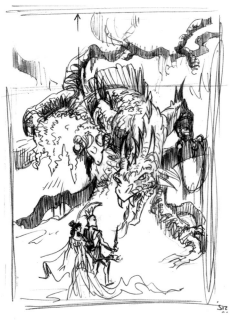

When I submitted the colour rough shown on this page the publishers responded that my dragon didn't look dangerous enough for what they wanted. They suggested I revert to a more traditional model of dragon, colouring it red rather than green and making it in general a lot more spectacular, so I produced the sketch at the bottom right of this page. I did this to about A4 (29 x 21cm/11½in x 8½in) size, with the title area marked off.

The publishers liked this far better, so I finalized the postures of the two human figures and refined the groping shapes of the tree's branches and roots.

Towards the finished artwork

As we've noted several times, before you launch into final artwork it's wise to make copious sketches and colour roughs to be sure you solve all the problems of shape and form while it's still easy to do so. Altering the shape or position of even a minor element at a late stage can be time-consuming, messy and frustrating, so you want to avoid it if possible. Moreover, the better you plan such details in advance, the more you can concentrate on colour and atmosphere when you're doing the final painting.

Once I'd finalized the appearance of the dragon, I needed to be certain in my own mind how I would treat the figures of Jason and Medea. Their body language had to convey very quickly to the viewer something of what was going on. Jason's stance had to indicate he was tantalizing the monster, holding its attention, nervous and aggressive at the same time. Medea needed to look a bit more devious as she prepared to strike with the juniper. Below are some of my experimental sketches. I generally draw these very small (about 4cm/ 1½in high) so that I can jot down the essentials very quickly. My colour rough of the figures was not much larger, at about 6cm (2½in) high.

I also did a number of little drawings of roots and branches and of the skulls and the stagnant pool at its base.

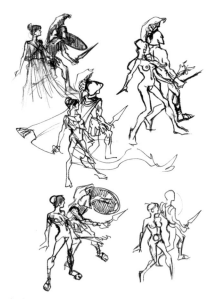

Left – My final rough drawing of the dragon's head.

Right –The finished illustration, intended for the cover of *The Story of Jason*.

Bottom left – Little doodles helped me get the two figures' body language right.

Below – My final colour rough of the two humans.

I did the final painting in gouache on illustration board to a size of about A3 (43 x 29cm/17 x 11½in). First I did a detailed pencil drawing. Then I laid on the red sky area, paling it down toward the dull yellow that would form the basis of the foreground. At this stage of a painting you often need to re-establish some of the outlines, which might otherwise get lost under the successive layers of paint.

Next I painted the details of the dragon's back and of the branches in that area. Overall, I worked from background to foreground, reserving the greatest contrasts of colour and tone for the last area I painted, the focal point comprising the dragon's head and the two figures.

Gouache is not the medium I'd choose if I were working on this project today. It has the disadvantage that whenever you have to lighten bright colours with white, you run the risk of their losing brilliance and, on being printed, looking 'chalky' – that misty area across the middle shows what I mean. To avoid this you need to put down areas of pale colour in the form of transparent washes. Today I more often use acrylics, which don't have this problem.

Unfortunately, after all my work, the project eventually foundered and the book was never published.

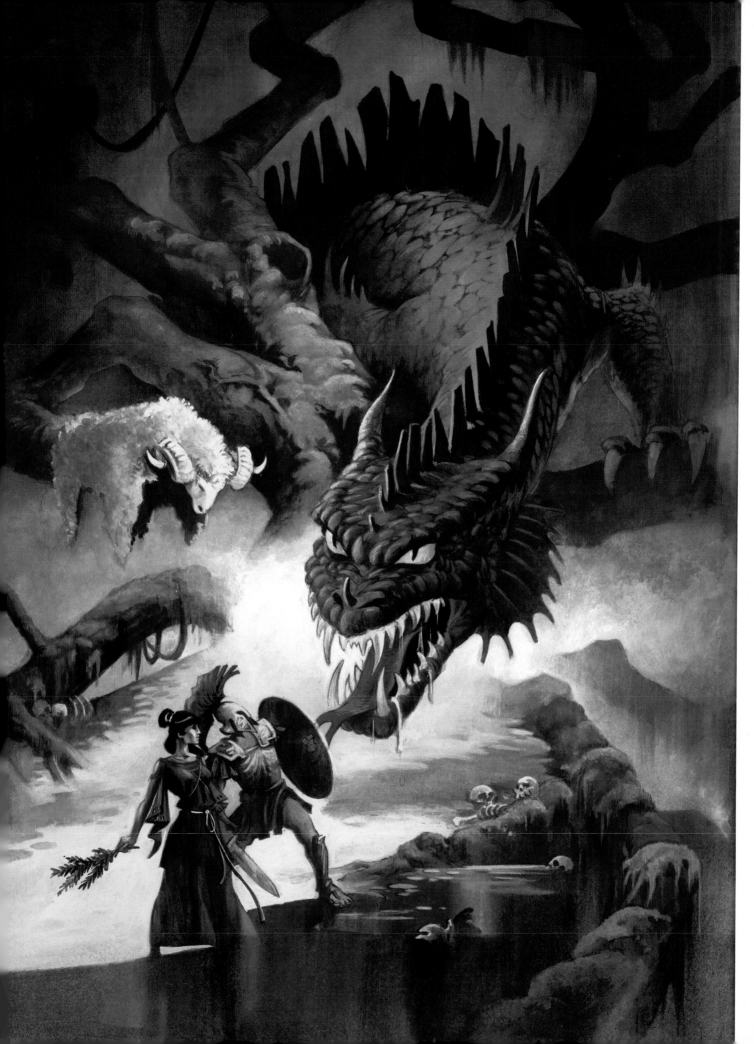

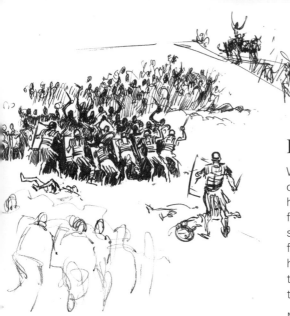

An illustration done for Rosemary Sutcliffe's *Eagle of the Ninth*: an exploratory sketch (**above**) and finished artwork (**below**).

Battle scenes

When you're illustrating educational books, you need to have a profound knowledge of your subject. Of course, the publishers of such books usually have experts on hand to advise you if necessary. But often you're asked to illustrate historical scenes for magazine articles, graphic narratives or novels where there is no chance of such support. You must educate yourself, through research. To paint a battle scene, for example, you need to know authentic details of weapons, armour, heraldry, harnesses, saddles, costumes, architecture… If painting a specific battle, you have to find out about the terrain on which the battle was fought and perhaps even what the weather was like that day.

Medieval battles, especially, commonly involved hordes of fighting men packed together so tightly they had no freedom of movement at all: many died simply through being crushed or trampled underfoot, rather than through any hostile move by the foe. For a convincing evocation of such hellish circumstances you have to find ways of depicting not just the cut and thrust of individual conflicts but also solid masses of struggling warriors.

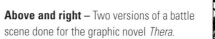

Above and right – Two versions of a battle scene done for the graphic novel *Thera*.

Below and left – The early steps and the finished rough for a depiction of the Charge of the Light Brigade. This illustration was done as a demonstration painting at Swindon College of Art in England for an audience of archaeological illustration students.

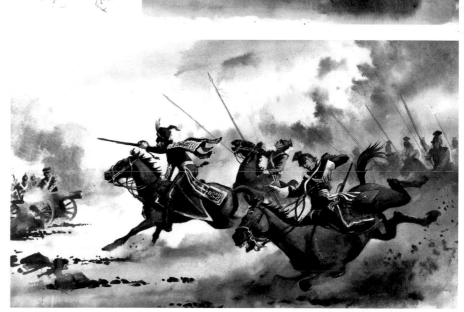

Left – The upper illustration shows the Battle of Hastings, the lower the Battle of Stamford Bridge. Both were done for Jane Shuter's *The Battle of Hastings* (Heinemann, 2004).

Right – The Charge of the Light Brigade.

The Battle of Helm's Deep

Some years ago I was commissioned to produce a series of illustrations based on J.R.R. Tolkien's *The Lord of the Rings* (1954–5). The unusual thing about this commission was that it was for a set of coffee mugs. This meant the artworks had to be very long and narrow. With the art printed around a curved surface, only about one-third of it could be seen at any one time, and that meant I had to give each illustration not one but three focal points. The challenge, then, was to ensure that whatever angle you looked from, what you saw was a well-composed picture.

This spread shows some of the stages in my production of the illustration of the Battle of Helm's Deep. I was aiming for a mythical, fairytale quality, so there's far less gore here than Peter Jackson put into the equivalent scenes in his much later film *The Lord of the Rings: The Two Towers* (2002).

Three steps in the creation of the composition rough (**above and below**) and the final artwork (**right**).

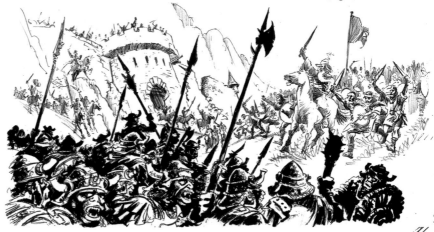

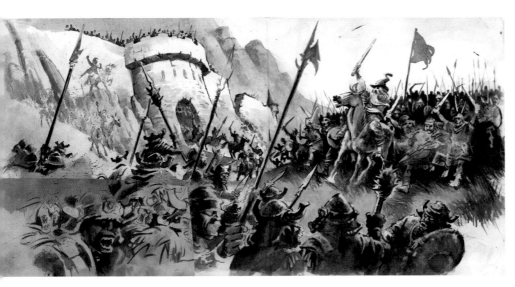

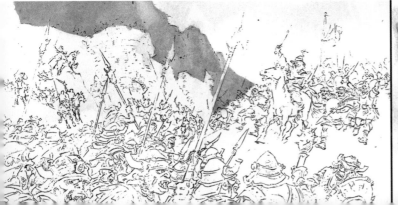

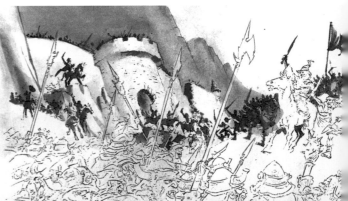

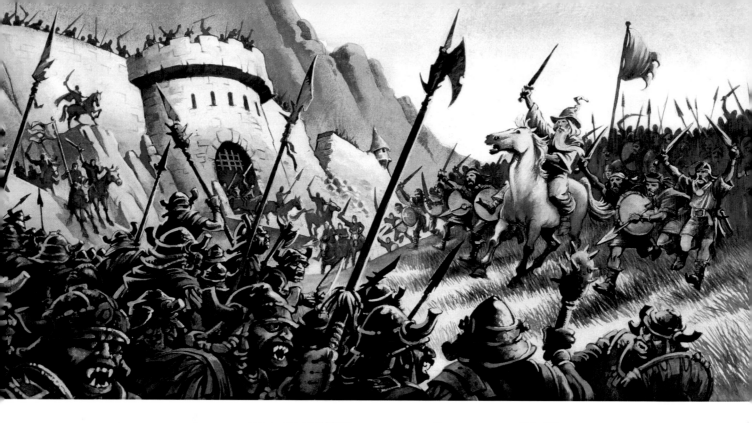

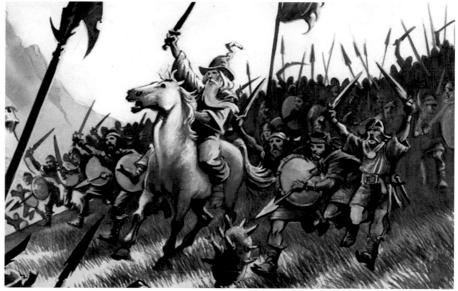

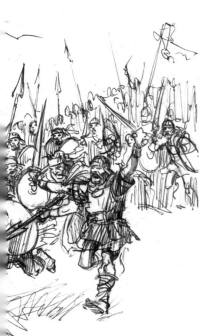

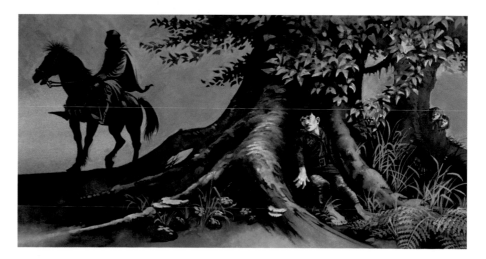

Above and above right – The closely packed horde of warriors behind Gandalf.

Left – The colour rough and, at the bottom of the page, the first steps in applying colour to the finished artwork. I first laid on a pale wash of warm yellow, then painted the background hills and city walls in transparent colour, and finally the figures in stronger, more opaque colour.

Right – Another in the series. In fact, I had to repaint it: it turned out that these intense colours wouldn't translate into ceramic glazes.

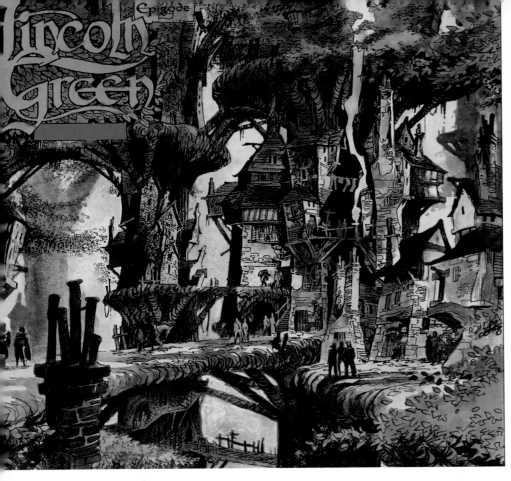

Imaginary places

Clients often ask for an illustration of an imaginary place – somewhere that's never existed. This can sometimes prove surprisingly difficult because, given such a free rein, your mind can go blank. I've found that the best approach is to get something down on paper, however rudimentary it may seem.

Right – An illustration for E.M. Forster's famous science-fiction novella *The Machine Stops* (1909).

Below – A city in space, along the lines of those in James Blish's novel *Earthman, Come Home* (1955) and its sequels. Here I was much influenced by the comic-book artist Alex Niño.

Lincoln Green

Opposite are some of the steps I took in creating a gigantic cathedral for a graphic novel, *Lincoln Green*, set in an alternative medieval England, one where the entire country is covered in giant trees – trees reaching heights of 2km (1¼ miles) or more. Because it's so dark and wet at ground level, towns have to be built on great platforms around the trunks, as in the illustration at top left of this page. Only religious buildings and the castles of the rich survive as conventional architecture, as in the picture above right . . . but to enjoy any sunlight these have to be on the same vast scale as the trees, and armies of labourers must wage a constant battle against roots that could undermine the foundations.

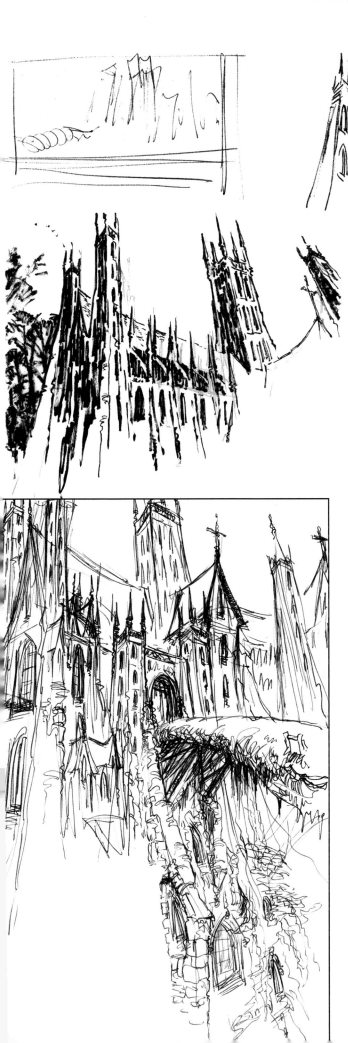

Top left – My very rudimentary first doodle for the cathedral, done in ballpoint pen and about 3cm (1¼in) high. It was a start – just! This led to the equally tiny drawing to its right, showing just a detail but exaggerating the vertical perspective. Once I'd visualized that aspect, I continued the exaggeration in subsequent drawings to give the building its impressive proportions, and things developed naturally to the final version (**bottom right**).

Graphic Dickens

The picture on the opposite page was the first frame of a comic-strip version of Charles Dickens's classic *A Christmas Carol* (1843): it shows the area around Scrooge's shop and warehouse as if from a nearby rooftop. This kind of general view at the start of a sequence in a graphic novel is often called, as in the movies, an establishing shot. It establishes in the viewer's mind a number of basic pieces of information – location, time of day, historical period, weather and so on.

This project required a fair amount of research on my part in order to pin down obscure details about Victorian costume and furniture. I used ballpoint-pen drawings to establish the composition of this first frame and the positions of the various buildings, then worked out what I wanted the characters in the story to look like.

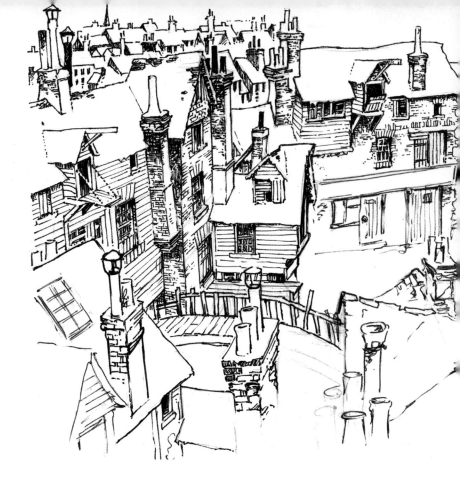

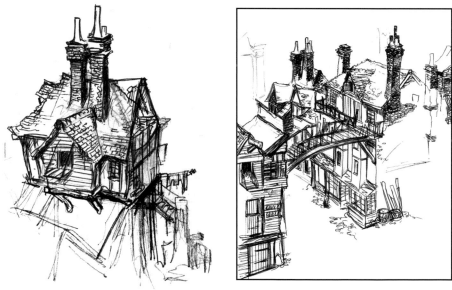

This page – Just a few of many sketchbook pages devoted to ancient rooftops and chimneys.

Opposite above – The finished picture.

Opposite below – The start of *A Christmas Carol*, showing how the frame fitted into its spread.

That done, I started to decide what should go into each frame and what the overall design of the page should be. In my sketch of the page's general layout I positioned the contents of each frame clearly, ensuring I'd left enough room for lettered panels and speech balloons. Once I was satisfied with the appearance of the page, I made a detailed pencil drawing of it on a clean sheet of heavy watercolour paper.

Next I inked over the drawing. I made the freckled halftones on the shadow side of chimneys and the textures on the ancient walls by putting a few drops of ink in a saucer, brushing them out to form a wet black area, then putting a piece of fine sponge into the ink and dabbing it onto the paper. Once the ink was dry, I added the colours using liquid watercolour.

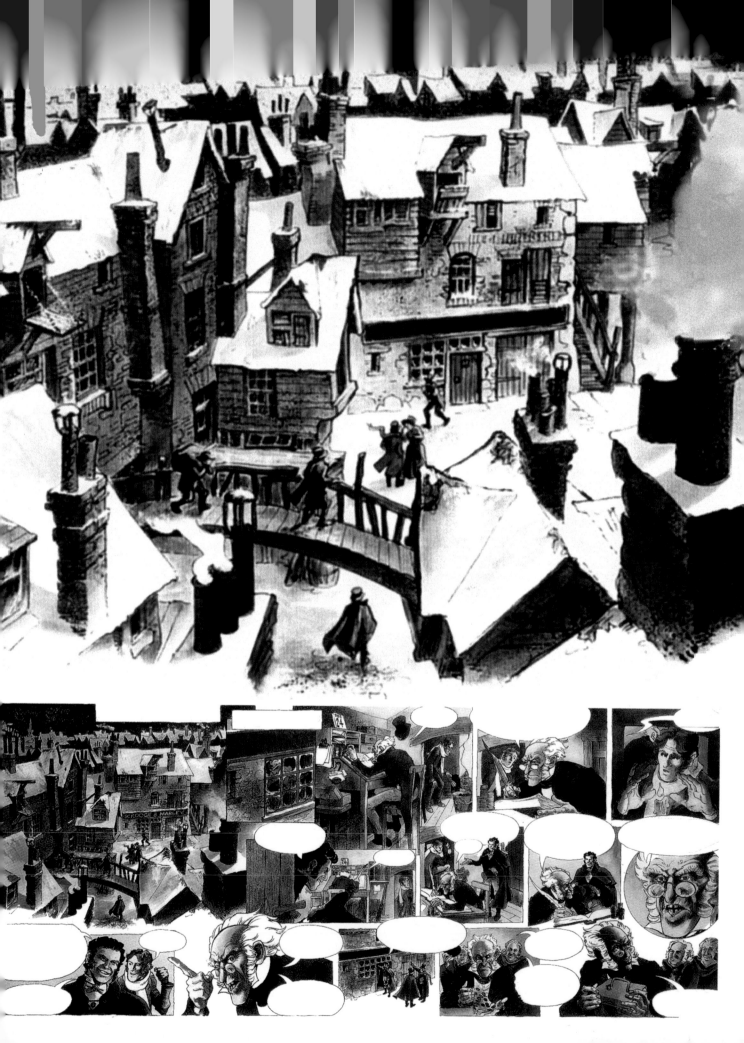

Comics and graphic novels

Graphic narrative is a kind of storytelling that demands a high level of drawing skill and an exceptional versatility. It is also very hard work, but the satisfaction more than makes up for that. I've always found graphic narrative irresistible – in fact, I spent much of my early professional career drawing little else.

Always bear in mind that an important function of every frame is to lead the reader's eye to the *next* frame. The drawing style you adopt, the page layout, the locations and the characters you create all need to be aimed towards one overriding end – a consistently good story. A story is well told if the reader identifies with one or more of its characters, and 'lives' the narrative through them, perceiving and understanding each fictional event almost like a personal experience.

Visual storytelling requires constant invention and reinvention: many of the locations and probably all of the characters will need to be drawn again and again without obvious repetition.

Below are a number of pages exemplifying this point. They come from a set of graphic-narrative adaptations published by the Danish firm Gutenberghus of Enid Blyton's *Secret Seven* stories. The publishers said the art had to be done in *ligne claire* ('clear line') style. This was the drawing style adopted by the Belgian artist Hergé, creator of Tintin; everything is drawn with a clean black outline. In this technique, black is used as a colour rather than to add shadow and emphasis, as it is in the *Harry Black* examples at the top left of the page opposite. Gutenberghus also prescribed the page layouts. There were ten or more frames on each page, most of them depicting all eight of the main characters (seven children and a dog), plus ancillary characters. I enjoyed drawing these stories, but I do remember wishing they hadn't been so *crowded*....

Above – Story frames from a number of different science-fiction comics.

Left – Pages from the Gutenberghus adaptations of Enid Blyton's *Secret Seven* stories.

Right – Part of a spread from the satirical strip *King Solomon's Swines*, lampooning H. Rider Haggard's *King Solomon's Mines* (1885), published in the humour magazine *Oink!* in 1995.

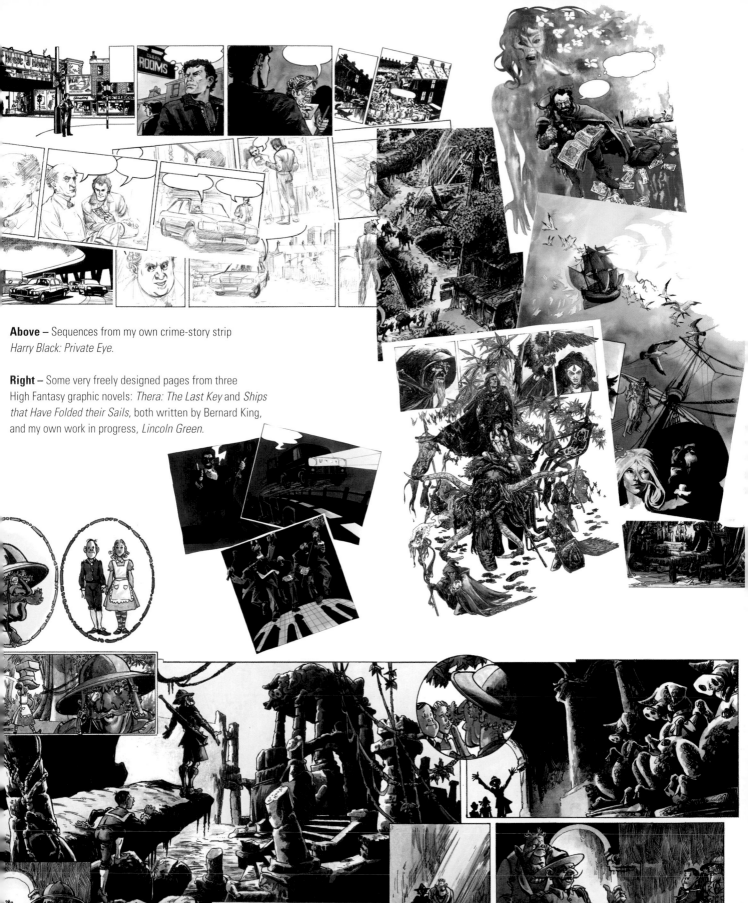

Above – Sequences from my own crime-story strip *Harry Black: Private Eye*.

Right – Some very freely designed pages from three High Fantasy graphic novels: *Thera: The Last Key* and *Ships that Have Folded their Sails*, both written by Bernard King, and my own work in progress, *Lincoln Green*.

Conclusion

At the beginning of this book I stated that the pictures would have as much to say as the words. If you follow my recommendations, and if you keep the book beside you as you do so, I hope you'll find that, each time you refer to it, the illustrations will have more and more to say to you. This is, after all, a book for those who wish to express their creativity visually.

To keep their message accessible, I've been careful to select drawings and paintings that depict the world more or less as the normal eye sees. This is not to suggest that the kind of imaginative thinking I'm seeking to promote is restricted to mimetic art – far from it. What I am saying, though, is that practice in drawing what you see in the real world around you will enhance your ability to imagine scenes, people, creatures and worlds that exist nowhere outside your mind… and, then, on the paper or canvas in front of you.

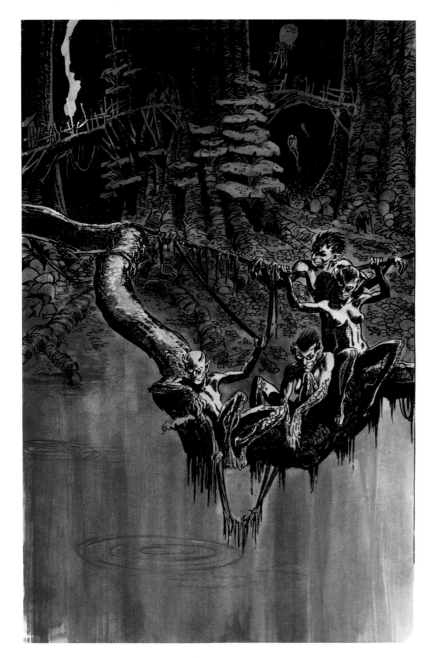

Above – Illustration for *Beauty and the Beast*, produced for an educational book.

Left – A narrative frame from the graphic novel *Lincoln Green*, still in progress at the time of writing.

Modern art education tends to undervalue the importance of drawing from observation, on the grounds that precise recording of the real world is unnecessary for a successful career in the visual arts. But this is to ignore the way that observation drawing stimulates the intuitive, creative right side of the brain. Observation drawing also expands our understanding of visual language, and leads to efficient visual thinking.

So let me leave you with one simple message: draw every day! If you make a habit of drawing anything and everything you see, you'll find yourself not only gaining new insights into the nature of the real world but also becoming more imaginative. In short, you'll find yourself beginning to draw – and to live – more creatively.

About the Author

Ron Tiner MA has been working professionally for nearly 40 years, providing illustrations for a very wide range of books, magazines, comics and graphic novels. He was instrumental in creating the course in Sequential Illustration for Swindon College of Art, where he taught for seven years. He now lives and works in Devon. He is the author of the best-selling title *Figure Drawing Without a Model*, also published by David & Charles (1992). His website can be found at www.rontiner.com

Acknowledgments

My thanks are due to the many publishers for whom I have worked over the past 30-odd years, for their permission to reproduce in this book the illustrations for which they hold copyright. Also to the staff of David & Charles for their support and help. My special thanks go to my old friend Paul Barnett, for his stirling work copyediting my text, and my very special thanks to my wife, without whose astute judgement this book would never have seen the light of day, and whose patience and support I don't deserve, but do appreciate!

Index